D1498131

Jaina Art

Jaina Art

Ananda K. Coomaraswamy

Munshiram Manoharlal
Publishers Pvt Ltd

ISBN 81-215-053-9
First published 1994
© 1994 Munshiram Manoharlal Publishers Pvt. Ltd., New Delhi
Originally published in
Journal of Indian Art nos. 127, 128, 1914

Typeset, printed and published by Munshiram Manoharlal Publishers Pvt. Ltd.,
Post Box 5715, 54 Rani Jhansi Road, New Delhi 110 055.

Contents

Jaina Art

Jaina Art

Jaina Art

Jaina Art

1

Introduction

T his paper forms a contribution to our knowledge of Jaina
painting and minor arts, concerning which nothing has yet
been published except the valuable *Miniaturen zum Jinacarita*
(Miniatures illustrating the Lives of the Jinas) published by Dr.
Hüttemann in the *Baessler Archiv* for last year (Band II, heft 2,
1913). The paintings are not only very important for the student of
Jain iconography and archaeology, and as illustrating costume,
manners and customs, but are of equal or greater interest as being
the oldest known Indian paintings on paper, and representing an
almost hitherto unknown school of Indian art, based like Rajput
painting on the old traditions, but carrying us back at least a century
and a half further than the oldest available examples of Rajput
pictures. It is, indeed, probable that when the Jaina's library of
Western India are made more accessible, they will be found to
contain illustrated manuscripts still older than the beginning of the
fifteenth century

The paintings and the minor arts of the Jaina libraries are here
regarded chiefly as documents of Indian art. In order, however, to
make them fully comprehensible, it is necessary to preface the
description and illustration of the actual paintings by a short
account of Jainism and of the legends of Mahāvīra and Kālakācārya,
which are the main subject of the pictures.

 1

2

Jainism[1]

The sixth century BC in ancient India was the central period of an age of intellectual dissatisfaction, scepticism and psychological experiment. The great monuments of this age are the Upaniṣads, the teachings of Buddha, and the teachings of Mahāvīra. All these documents reflect the movement of thought, mainly of Kṣatriya origin, which endeavoured to penetrate more deeply than of old the meaning of life, and in a manner scarcely contemplated by the old Vedic theologies, and certainly not achieved by their ritual.

We are here concerned only with the religion founded by Mahāvīra, the Great Hero, the Jina, the Conqueror. From correspondences in Jaina and Buddhist tradition it is practically certain that Mahāvīra, otherwise called Vardhamāna (Jñātiputra) is identical with the Nigaṇṭha Nātaputta who is referred to in Buddhist texts as the leader or a rival sect in the time of the Buddha himself. Thus the founder of Jainism, like the Buddha, taught in the fifth century BC.

[1]This section is largely based on *The Jainas*, by J.G. Bühler and J. Burgess (London, 1903); and on the various publications of Jacobi elsewhere cited.

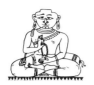

What he taught, and the manner of his teaching, also closely paralleled the doctrine and ministry of Buddha. Jainism is essentially an ethical philosophy intended for ascetics, the Niganthas, "Freed of all Bonds," who leave the world to dedicate their whole lives to the search for truth, and its proclamation. They practised a more severely ascetic rule than that of the Buddhists. As in Buddhism, however, there was also recognised a laity, who without renouncing the world, still adhere to the Jaina doctrines, and support the Jaina mendicants. The members of the lay community, if they could not reach the highest goal, could still walk on the path towards it.

Though retaining one and the same body of doctrine, the Jaina community as a whole was early divided into two parts, the Digambaras, "Clothed with the sky," whose ascetics wear no clothing whatever, and the Śvetāmbaras, who are "Clothed in white," and who alone possess an order of nuns. The Jaina teaching, like that of Buddha, takes for granted the Brahmana doctrines of Karma (Deeds, Causality) and Saṃsara (the Ocean of Rebirth). Its highest goal is Nirvāṇa or Mokṣa, the setting free of the individual from the Saṃsāra. The means to this end are the three Jewels of Right Knowledge, Right Faith, and Right Walk. Just what the Buddha is to the Buddhists—originally a man like other men, who nevertheless by his own power has attained to omniscience and freedom, and out of pity for suffering mankind teaches to them the way of salvation which he has found—that is the Jina to the Jainas. The Jina, the Conqueror, is variously known as Kevalin (Omniscient), Buddha (Enlightened), Mukta (Delivered), Siddha (Perfected), Arhat (Adept), and Tīrthakara, "the Finder of the Ford" through the Ocean of Rebirth. The last title alone is peculiar to the Jainas, all the others belonging to the common usage of Brāhmanas and Buddhists as well as Jainas.

The Jainas definitely differ from the Buddhists in the details of their cosmology, and more important, in the fact that they postulate

 3

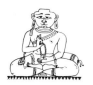

a *place* of purity beyond the heavens, to which place the perfected souls depart at death, nevermore to return. This place, however, is described as *aloka*, a non-world, and thus in its significance corresponds to the Buddhist "Void" and the unconditioned Brahman of the Brāhmaṇas.[1] Nevertheless, the liberated Jina, probably through the influence of lay sentiment and the growth of *bhakti* (loving devotion), came in later times to be regarded as a god, to whom prayers might be addressed, who might be represented in images and worshipped in temples, and who may even be spoken of as the Creator. The Jains also differ from the Buddhists, and differed from the outset, in their much greater stress on asceticism, often of an extreme character, and in their exaggerated care for animal life.

Later Jaina tradition further added to the historical individual who founded the order, twenty-three preceding Jinas, of whom the first (Ṛṣabha) is said to have lived more than a hundred billions of oceans of years ago.

While the Buddhist community no longer exists in India, except in Nepal and Ceylon, but is represented throughout Eastern Asia, the Jainas have survived in India to the present day, but have not established adherents abroad. The Jainas are to be met with in nearly every large Indian town, chiefly amongst the merchants. They have been politically, and are still economically powerful. To them the architectural splendour of many of the cities of Western India is largely due; as likewise, that of the great temple cities of Satruñjaya and Girnār, and the beautiful temples at Mount Ābu. They now occupy an important position chiefly in Gujarat, Rājputānā and the Panjāb, and also in Kānara.

[1] The idea of a *place* to which departed perfected souls go, is probably a later materialistic interpretation. In the same way, even the Buddhists occasionally reckon Nirvāṇa as a local "place of departed Buddhas," situated above the heavens (Copleston, *Buddhism in Ceylon*, sec. ed., p. 245). Cf. R.F. Johnston, *Buddhist China*, 1913, p. 97.

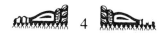

In course of time the Jaina community achieved (or condescended to) a more systematic organization. There came into existence monuments, monasteries and schools. To this development of a cult corresponded a literary, scientific and artistic activity, of which the earliest results brought the doctrine into fixed forms. Probably most of the original canonical Jaina literature thus took shape early in the third century BC. Bhadrabāhu, the author of the *Kalpa Sūtra* (Lives of the Jinas, particularly Mahāvīra) is stated according to Jaina tradition to have died 170 or 162 years after Mahāvīra himself (528 BC according to Jaina tradition); that is to say, Bhadrabāhu died 358 BC. The *Ācārāṅga Sūtra*, which confirms the traditions of the *Kalpa Sūtra* regarding the life of Mahāvīra, is the first of the eleven *aṅgas* or sections of the canon of the third century. All this literature was probably in the main handed down orally until the time of the Council of Valabhi AD 454 or 467, when new redactions were prepared and the method of teaching novices from books was substituted for purely oral instruction. At that time, and even subsequently, additions may have been made. In any case, it is certain that the *Kalpa Sūtra*, including the main account of the life of Mahāvīra, "has been held in high esteem by the Jainas for more than a thousand years".[1] The oldest available manuscript of the *Kalpa Sūtra* is here spoken of as MS. I.O., from which illustrations are reproduced in figures 3, 5, 9, 12, 45, 50, 51. A MS. commentary dated AD 1307 is also known. But no doubt the contents of the manuscripts have been handed down substantially in their present form at least from the fifth century AD.

[1] Jacobi, *SBE*, vols. XXII, LIII.

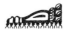 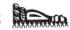

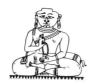

3

Life of Mahāvīra and Other Jinas[1]

At the close of his allotted period of existence in heaven, where he had dwelt for twenty ages subsequent to his last incarnation, Mahāvīra, the last of the Tīrthakaras, took conception in the womb of Devānandā, the wife of the Brāhmaṇa Ṛṣabhadatta, in the town of Kuṇḍagrāma (probably a suburb of Vaiśālī, capital of Videha or Mithilā, the modern Tirhut).

That night the Brāhmaṇī Devānandā lay in fitful slumber, between sleeping and waking, and she dreamt fourteen auspicious and blessed dreams, to wit: of an elephant, a bull, a lion, the lustration (of Lakṣmī), a garland, the moon, the sun, a flag, a vase, a lotus pool, an ocean, a celestial mansion, a heap of jewels, and a flame. She awoke from these dreams happy and contented; and firmly fixing the dreams in her mind, she rose from her couch. Neither hasty nor trembling, but with the even gait of a royal swan, she sought the Brāhmaṇa Ṛṣabhadatta and greeted him. Then she

[1]Condensed from the *Kalpa Sūtra* and *Ācārāṅga Sūtra*, translated by Jacobi, *SBE*, vol. XXII.

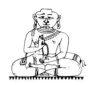

sat down in a rich state chair; calm and composed, with folded hands, she related to him the dreams. He saw that they foretold a son; beautiful and perfect and clever, who would become acquainted with all branches of scripture, grammar and science. She accepted the interpretation, and he and she rejoiced together.

Meanwhile Śakra (Indra), wielder of the thunderbolt, rider of Airāvata, wearing robes as spotless as the pure sky, and trembling earrings of bright gold, sat on his throne in the council hall Sudharman in heaven. He who is ruler of heaven and all the gods of heaven and earth, was then enjoying the divine pleasures, such as music and playing and story-telling. He likewise surveyed the whole land of Jambudvīpa (India) with his all-embracing gaze, and he saw that Mahāvīra was conceived in the womb of Devānandā. Trembling with delight, he rose from his throne, and descending from the jewelled footstool, he cast his seamless robe over his left shoulder and advanced in the direction of the Holy One. Then he knelt and touched the ground with his head thrice, and joining the palms of his hands, raised them above his head and said: "Reverence to the Saints and Blessed Ones, the Masters, the Path-makers (Arhats, Bhāgavats, Ādikaras and Tīrthakaras), the perfectly enlightened ones; to the highest of men, the lions amongst men, the lotus-flowers of humanity; to the highest in the world, the guides of the world, the lights of the world; the givers of safety, of life and of knowledge; the givers and preachers of law; the possessors of boundless wisdom and intuition; the conquerors and the saviours; those who have reached a stainless and undying bliss whence there is no return, those who have conquered fear. Reverence to the venerable ascetic Mahāvīra, last of the Tīrthakaras, whom the former Tīrthakaras foretold. I here adore the revered one whom I see, may he from there see me." So saying, Śakra bowed again and returned to his throne.

It immediately occurred to him that it never had happened nor ever could happen that any Arhat, Cakravartin or Vāsudeva had

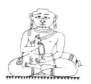

taken birth in a low or degraded or in any Brāhmaṇa family, but only in noble families of pure descent. "This is the first time that an Arhat has taken conception in an unworthy family;[1] however, it has not yet happened that one has ever been born in such a family. I shall therefore cause the venerable ascetic Mahāvīra to be removed from the Brahmanical quarter Kuṇḍagrāma and from the womb of the Brāhmaṇī Devānandā, and to be placed as an embryo in the womb of the Kṣatriyāṇī Triśalā, wife of the Kṣatriya Siddhārtha; and the embryo of the Kṣatriyāṇī Triśalā to be placed in the womb of the Brāhmaṇī Devānandā." Thus reflecting, he called Hariṇegamesi, the commander of his infantry; and he instructed him as foresaid, to exchange the embryos, and to return and report the execution of the command.

Hariṇegamesi bowed and departed, saying: "Just as your Majesty orders." He descended from heaven towards the north-eastern quarter of the world, and assumed a material form; and so he passed with the high swift movement of a god, over continents and oceans, till he reached the town of Kuṇḍagrāma and the house of the Brāhmaṇa Ṛṣabhadatta. There he bowed eight times to Mahāvīra, and cast the Brāhmaṇī Devānandā into a deep sleep, and all her retinue; removing all that was unclean, he brought forth what was clean, and placed the embryo of the venerable ascetic Mahāvīra in the womb of the Kṣatriyāṇī Triśalā, and the embryo of the Kṣatriyāṇī in the womb of the Brāhmaṇī Devānandā. And having so done, he returned whence he came. With the high swift movement of a god he passed over oceans and continents and reached the heavens and the throne of Śakra, and reported the fulfilment of the command. This befell on the eighty-third day after conception, in the middle of the night.

On that night the Kṣatriyāṇī lay on her couch, twixt sleeping and waking, in her bower, whereof the walls were decorated with

[1]That is to say, so regarded by the Jainas, whose philosophy and membership, like that of the Buddhists, was primarily of Kṣatriya origin.

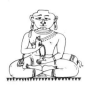

pictures, and the ceiling painted; the chamber was fragrant with the scent of flowers and perfumes, and the couch was covered with a mattress of a man's length, with pillows at head and foot, raised on both sides and hollow in the middle, covered with a cloth of figured linen, hung with red mosquito nets, and furnished with all the comforts of a bed, such as flowers and sandal powder. Then there came to her the fourteen auspicious and delightful dreams that the Brāhmaṇī Devānandā had formerly dreamt, to wit: a great lucky elephant, marked with auspicious signs, and four-tusked; a lucky bull, whiter than the petals of the white lotus, sleek and well-proportioned, foreboding innumerable happy qualities; a playful beautiful lion, whiter than a heap of pearls—his tail waved, and his beautiful tongue came out of his mouth like a shoot of beauty; Śrī, the goddess of beauty, seated on a lotus, laved by attendant elephants; a garland of *mandāra* flowers hanging down from the firmament, incomparably fragrant, and haunted by swarms of bees; the moon, white as the milk of cows, or as a silver cup; the great red sun, whose thousand rays obscure the lustre of all other lights; a green flag, fastened to a golden staff, with a tuft of soft waving peacock feathers; a full vase of gold, filled with water-lilies; a lake of lotuses, resorted to by swans and cranes and ducks, pleasing to heart and eye; the ocean of milk, beauteous as Lakṣmī's breast—a splendid and a pleasant spectacle as its waters tossed in moving, ever-changing, excessively high waves, traversed by porpoises and whales; a heavenly mansion of a thousand and eight columns, decked with gold and gems, hung with pearl garlands and decorated with various pictures, filled with music like the sound of heavy rain, perfumed delightfully and full of light; a heap of splended jewels, high as Meru, illumining the very firmament; and a smokeless, crackling fire, flaming high as if to scorch the very heavens. From these auspicious, happy dreams the Kṣatriyāṇī Triśalā awoke, and all the hair on her body rose up in joy. She rose from her couch, and neither hasty nor trembling, but with the gait

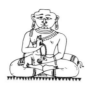

of a royal swan, she sought the couch of the Kṣatriya Siddhārtha, and spoke to him with pleasant, gentle words, and with his leave she sat on a chair of state, inlaid with precious stones in various patterns. She related the fourteen dreams, and asked her lord what they might portend. He foretold that she would give birth to a son, who would establish the fame of their family: a beautiful boy who should be acquainted with all branches of scripture, grammar and science, and become a lord of the earth. Then the Kṣatriya and Kṣatriyāṇī rejoiced together; and Triśalā returned to her own couch, and waked till morning, lest these good dreams should be counteracted by any bad dreams following.

At daybreak, Siddhārtha called for his servants, and ordered them to prepare the hall to audience. He himself went to the royal gymnasium and practised exercises, such as jumping, wrestling, fencing and fighting, till he was wearied. Then he was well shampooed; and when he was refreshed, he entered the bath-room. That was an agreeable chamber; it had many a window, and the floor was covered with mosaic of precious stones. He seated himself on the bathing stool, inlaid with gems, and bathed himself with pure scented water. Then he dried himself with a soft towel, and donned a new and costly robe, with jewels rings, and strings of pearls. He seemed like a tree granting all desires. A royal umbrella was held above him, as he proceeded from his bath and took his seat in the hall of audience, surrounded by chiefs and vassals, ministers, merchants and masters of guilds, knights and frontier-guards—a very bull and lion amongst men. On the one side of the throne he had set eight chairs of state; and on the other a curtain, figured with various pictures, was drawn towards the inner rooms of the palace; and behind this chair was placed a jewelled chair of state for the Kṣatriyāṇī Triśalā. Then Siddhārtha sent for the interpreters of dreams; and they, bathing and donning clean court robes, came from their houses and entered Siddhārtha's palace, and saluting him with folded hands they took their seats on the chairs of state.

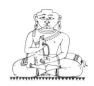

Meanwhile Triśalā took her seat behind the curtain. Siddhartha recounted the dreams to the interpreters, and they, after consideration and discussion, replied to him: "O beloved of the gods, there are thirty Great Dreams enumerated in our books, and of these, those who dream fourteen dreams are the mothers either of Universal Emperors or of Arhats, and hence the Kṣatriyāṇī, having seen fourteen, will be the mother either of a Cakravartin or of a Jina." The king Siddhārtha gladly accepted this interpretation and dismissed the interpreters with gifts; and the lady Triśalā returned to her own apartments, neither hasty nor trembling, but with the even gait of a royal swan, glad and happy.

Now from the moment when the venerable ascetic Mahāvīra was brought into Siddhārtha's family, their wealth and their liberality and popularity increased daily; and on this account it was decided to name the child Vardhamāna, the Increaser.

While still in the womb, the venerable ascetic Mahāvīra made the resolution not to pluck out his hair and leave the world during the lifetime of his parents.

During the remaining time of her pregnancy, the Kṣatriyāṇī Triśalā guarded herself from all sickness, fear and fatigue, by suitable food and clothing and pleasant diversions and occupation, frequently resting on soft couches, and thus bearing her child in comfort. And after the lapse of nine months and seven and a half days, in the middle of the night, when the moon was in conjunction with the asterism Uttaraphālguni, Triśala, perfectly healthy herself, gave birth to a perfectly healthy boy.

That night was an occasion of great rejoicing; the universe was resplendent with one light, as the gods and goddesses descended and ascended, and great was the noise and confusion of the assembly of gods. These gods—the Bhavanapati, Vyantara, Jyotiśka and Vaimānika—appeared to celebrate the feast of inauguration (*abhiṣekha*) of the Tīrthakara's birthday. Siddhārtha proclaimed a ten days festival in his city, of remission of taxes, almsgiving, and

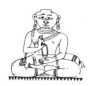

so forth. On the twelfth day there took place a royal banquet, and it was announced that the boy's name would be Vardhamāna.

Beside this he is called Śramaṇa, or ascetic, because he is without love and without hate; and because he stands fast in midst of dangers and fears, and patiently bears hardships and calamities, and is indifferent to pleasure and pain, obedient to a chosen discipline, he is called Mahāvīra, the Great Hero, by the gods.

Mahāvīra dwelt in Videha thirty years, before his parents departed to the world of the gods; and then only, with the permission of his elder brother and the great men of the kingdom, he fulfilled his vow. The Laukāntika gods appeared to him, saying: "Victory to thee, O bull of the best Kṣatriyas! Awake, reverend Lord of the World! Establish the religion of the law which benefits all living beings in the whole universe!"

Mahāvīra had already perceived that the time for his renunciation (niṣkramaṇa) had come. He made a suitable distribution of all his wealth. This distribution of gifts occupied a whole year, at the end of which time, the four orders of gods, descending from heaven, proceeded to the abode of Mahāvīra. As they arrived in the Kṣatriya quarter of Videha, Śakra (Indra) descended from his chariot, and went apart; and he created by magic a divine pedestal (deva-chamda), with a throne and footstool. Then proceeding to the venerable ascetic Mahāvīra, Śakra circumambulated him thrice from left to right, and placing him upon the throne, bathed him with pure water and precious oils, and robed him in the lightest of figured muslins, and garlands of pearls and precious gems. Then the god again created by magic a splendid palanquin called candraprabhā (moon-radiance), adorned with pictures and bells and flags, and provided with a throne; it was conspicuous, magnificent and beautiful.

After completing a three days fast, the ascetic Mahāvīra ascended the throne and took his seat in the palanquin; in front it was borne by men, and by the gods behind,—the Suras and Asuras,

Garuḍas and Nāgas. Its movement was accompanied by the sound of musical instruments in the sky and upon the earth: and thus it proceeded from the Kṣatriya quarter of Kuṇḍapura along the highway towards the park called Jñātri Shaṇḍa. Just at nightfall the palanquin came to rest upon a little hillock beside an Aśoka tree: Mahāvīra descended, and took his seat beneath the tree, with his face towards the East. He removed his ornaments and fine clothes; and tearing out his hair in five handfuls, he obtained *dīkṣā*, entering upon the homeless life of a friar, adopting the holy rule, and vowing to commit no sin. At the same time he donned a divine garment, which he accepted from Śakra, who received the rejected ornaments and fine clothes and removed them to the Ocean of Milk[1] At

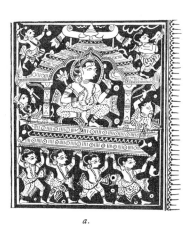 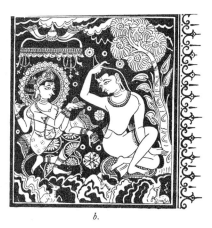

a. *b.*

Illustrations from the Berlin MS. IC. 2367 of the Museum für Völkerkunde, after Hüttemann, *Miniaturen zum Jinacarita,* Baessler Archiv, 1913.

a. Mahāvīra carried by the gods in a palanquin. Cf. MS. C.B., folio 33 (labelled *Śibikā*).
b. The *Dīkṣā* of Mahāvīra. Mahāvīra, seated beneath an Aśoka tree, plucks out his hair, while Indra (Śakra) offers him a divine robe. Cf. Figs. I, 26.

[1]Thus, according to the *Ācārāṅga Sūtra* and the pictures. Another MS. states that the ornaments, etc., were received by Vaiśramaṇa (who is never represented

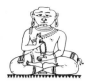

the moment of Mahāvīra's obtaining *dīkṣā*, the whole universe of men and gods became suddenly perfectly silent and motionless, like the figures in a picture.

Mahāvīra obtained the degree of knowledge called *Manah-paryāya*; and he resolved to neglect the care of his body for twelve years, bearing with equanimity all pleasures and pains, whether arising from divine powers, from men or from animals. The twelve years duly passed in blameless wandering, the practice of religious discipline, and the patient endurance of pain and pleasure. It was in the thirteenth year that Mahāvīra, seated in deep meditation beside a śāl tree, near the town Gṛmbhikagrāma, attained to Nirvāṇa, and the unobstructed, infinite and supreme knowledge and intuition of a *Kevalin* (syn. *Jina, Arhat*). Then he became aware of all states of gods or men or demons, whence they came and whither they go, their thoughts and deeds; he saw and knew all circumstances and conditions of the whole universe of living things.

When the venerable ascetic Mahāvīra had thus reached the highest intuition and knowledge, the time had come for him to teach the doctrine of the Jinas. To his end the gods prepared for him a *samavasaraṇa*, and entering this by the eastern gate, he took his seat upon the throne, and taught the Divine Law to gods and men.

During a period of nearly thirty years following, Mahāvīra wandered to and fro, spending the rainy season in different cities, founding a great community of monks and lay votaries, and teaching the five great vows, the doctrine of the six classes of living beings, and so forth. At the end of that time, in the town of Pāpā, the venerable ascetic Mahāvīra died, cutting asunder the ties of birth, old age and death, becoming a Siddha, a Buddha, a Mukta, one who

in the pictures). The *Kalpa Sūtra*, though it mentions the divine robe, and thus implies the presence of a divine donor, distinctly states that Mahāvīra was quite alone when he obtained *dīkṣā*; this must be understood to mean that no other human being was present. See also the descriptions of the pictures; and the discussion by Hüttemann, *loc. cit.*, pp.68-70.

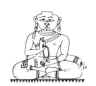

is finally released, never more to return, entering the paradise of perfected souls (Īṣatpragbhāra), above the world and beyond the heavens of the gods. The *Kalpa Sūtra* further states that Mahāvīra had nine Gaṇas and eleven Gaṇadharas, i.e., nine companies or orders of monks, established by eleven teachers, his disciples.

The *Kalpa Sūtra* proceeds to give the lives of the Jinas Pārsva, Ariṣṭanemi or Nemināth, and Ṛṣabha and a list of the twenty Tīrthakaras who lived between the ages of Nemināth and Ṛṣabha. The life-stories of Pārsva, Nemināth and Ṛṣabha are identical in nearly all respects with that of Mahāvīra, with only a difference of the names of their parents, and a few other particulars. The lives of these Jinas are illustrated in the pictures in a comparatively summary fashion, while the remaining twenty are usually represented in a single illustration.

A special legend is, however, attached to Pārsva, and accounts for the canopy of seven snake-hoods always represented above his head in pictures and sculptures. It is said that a *deva* of the name of Meghakumāra (Cloud-prince) attacked the Arhat with a great storm, whilst he was engaged in practising the *Kāyotsarga* austerity (exposure to all weathers): very much as Māra attacked the Buddha at Bodh-Gayā. And just as the *nāga* Mucalinda, whom Buddha had benefited in a former life, then came to protect him by spreading his hoods above his head, so the *nāga* Dharaṇendra and his consort the *yakṣiṇī* Padmāvatī, whose lives had been restored by the Jina in a former existence, now came to protect him, the former spreading his many hoods over the head of his benefactor, the latter holding over him a white umbrella.

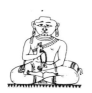

4

Summary of the Story of Kālakācāryā[1]

BIRTH AND THE DETHRONEMENT OF GARDABHILLA

There was a town in Bhāratvarṣa, named Dharāvāsa. The king of that town hight Vajrasiṃha, and his chief queen was the peerless Surasundarī; they had a son expert in every science, and he hight Kālakakumāra. One day he was returning from a drive, and saw a Jaina priest preaching in the mango park. He approached the monk, bowed, and listened; and was converted and joined the order, to his father's great grief, together with a numerous company of princes. When he had completed his religious studies, his teacher established him as head of the order in his own stead. With five hundred monks he proceeded to Ujjayinī, and there remained for some days, preaching. Meanwhile there also arrived a party of pious nuns, amongst whom was the beautiful and devout Sarasvatī, Kālakācārya's[2] younger sister.

[1] Based on the translation by Jacobi, *Zeitschrift der Deutschen Morgenländischen Gesellschaft*, vol. XXXIV, 1880, p. 247 seq.

[2] I.e. Kālaka, formerly *Kumāra* (prince), now *Ācārya* (adept).

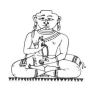

Gardabhilla, king of Ujjayinī, passed that way, and seeing Sarasvatī, desired her, and carried her off against her will, calling out to her brother for help. Kālakācārya remonstrated with the king, saying that if he set a bad example, law and other would be destroyed, and so forth; but in vain. The infatuated king was not to be persuaded. For a blind man does not see what is visibly before him; but one blinded by passion sees what does not exist—lotus blossoms, the moon's disk, and a whole catalogue of beauties, where in sooth exists naught but unclean flesh.

Kālakācārya summoned the fourfold Synod; but that also was vain, and Kālakācārya made a vow, either to drive the king out of his kingdom, or himself to go the way of those who are the enemies of the faith and destroy piety. So saying, the Wise One reflected that he must have recourse to cunning, since the king was brave and powerful, and expert in ass-magic (*gaddhabhīe mahāvijjāe*). He dressed himself as a madman, and frequented cross roads and market places, calling out "If Gardabhilla is king, what of that? If his zenana is fair, what of that? If I go begging, what of that? Or if I sleep in a deserted house, what of that?" When the townsfolk heard the Wise One crying out in this way, they said "Alas, the king must be committing some sin, since Kālakācārya, the refuge of the virtuous, has deserted his Order and wanders in the town a madman; alas! alas!"

When the ministers heard that all the folk of the city blamed the king in this fashion, they said to him, "Sire, do not so, but set free the nun, since great harm is coming of it; and he who injures the monk, plunges himself into a sea of misfortune." But the king was wrath, and recommended them to reserve their exhortations for their grandmothers. They were astounded, and murmured, "Who can restrain the ocean when it overflows its banks?"

Now the Wise One left Ujjayinī and went to the land of the Śaka clan. The princes are there called Shāhis, and their overlord the Shāhan Shāhi. Kālakācārya remained at the court of one of the Shāhis, and brought him under his power by means of *mantras* and

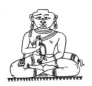

tantras. One day when the Shāhi was talking with the Wise One, the door-keeper announced the messenger of the Shāhan Shāhi. He was brought in and gave the king a present, a sword sent by his master. Thereat the Shāhi's face darkened like the sky before rain. Then the Wise One reflected: "I see a strange thing; for when servants receive an honorable gift from their masters, they are wont to be glad like peacocks at the sight of clouds. I will enquire what this may mean." When the messenger had departed, the Wise One asked the Shāhi why he was thus downcast at receiving a mark of favour from his master. "Honorable sir," he replied, "that was not a sign of favour, but of anger. When he is wrath with us he sends a sword, and we must slay ourselves therewith, and since he is mighty, his commands must be obeyed." The Wise One enquired, "Is he angry only with thee, or with others also?" The Shāhi answered, "He is angry also with the ninety-five other Shāhis, since the sword bears the number 96." The Wise One said, "If so, do not slay thyself." But the Shāhi replied, "Then he will destroy our whole race; but if I am dead, he will spare others. The Wise One said, "If so, send a messenger to the other princes, to say that we shall set out for Hindustān." The messenger was sent and the ninety-five Shāhis appeared. Then the first Shāhi asked the Wise One what was to be done next. He replied, "Cross the Indus with an army and baggage, and go to Hindukadeśa."

So they did and came to Surāṣṭra. Then it was the rainy season; so they parcelled out the land and remained there while the roads were impassable. Then came Spring with his white lotus flowers, like a king with white umbrellas; when white herons are to be seen like white clouds before the first rains; honoured by flamingoes like a Jina by famous kings; when rivers are clear as good men's thoughts, the heavenly regions bright as the words of skilful poets, the welkin free from earthly stain as the body of the highest ascetic; when the *saptacchada* trees are decked with flowers as *munis* are decked with virtue; when the nights are gay with stars; when earth shines bright with all her fields of ripe corn, beloved of the proud

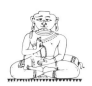

bellowing bulls and happy herdsmen; when by night the bosom of the earth, as it were, is bathed in a stream of moonray-nectar; when travellers are led astray by the sweet songs of the careful farmers watching the green rice-fields; when the *cakravāka* wakes to the accomplishment of his dreams of love.

When Kālakācārya beheld such prowess of the Spring, he spake to the Shāhis, for the fulfilment of his wishes, saying, "Ha! why do ye idle here?" They said, "Tell us what to do." The Wise One answered, "Capture Ujjayinī, the bulwark of Mālwā; there shall ye find good living." They answered, "With a good will, but we have no resources, for we brought with us nothing more than bare necessities." So the Wise One with magic powder changed all the potter's stuff to gold, and said, "Take this for your needs." They set out accordingly for Ujjayinī.

When Gardabhilla heard of the enemy's approach, he marched forth and met them on the borders of his country and joined battle He was defeated and his army dispersed like clouds before the wind. He drew back into his city with the remnants of the army. The victors laid siege, and made daily assaults. One day when they were storming the fort, they saw that it was empty; and they asked the Wise One what this might mean. He replied, "Today is the eighth, when Gardabhilla fasts and practises his ass-magic; go see if there be a she-ass anywhere upon the walls." They saw that there was an ass, and showed it to the Wise One. He said, "When she makes a great outcry on the accomplishment of Gardabhilla's rites, immediately every creature two- or four-footed in our army will fall to the ground with blood pouring from his mouth. Take, therefore, all that are two- or four-footed and withdraw two miles from the walls; but give me a hundred and eight accomplished bowmen." So did they

The Wise One said to the bowmen, "When the ass opens her mouth to speak, stop her mouth with arrows before she utters a sound; for if she does so, we may shoot never more. Therefore wait in patience, with bows drawn to the ear." So did they. They stopped the ass's mouth with a hail of arrows, so that it could not utter any

sound; and the magic beast fell dead outright. The Wise One ordered his men to take the army prisoner; they stormed the walls and entered Ujjayinī. Gardabhilla was captured alive and brought in chains to the Wise One's feet. He said, "Shameless and vile wretch and evil-doer, soon art thou despoiled of power. So have we done because thou didst shame a nun unwilling, and didst contemn the Synod. He who robs a nun of honour, sets a fire at the root of the welfare of the Jaina faith. Long, indeed, shalt thou whirl about in the *saṃsāra*, suffering many ills and the more so in this life than any other. Scourging, imprisonment and disgrace are the flowers of the tree of resistance to the Synod. Thou dost not merit that we should parley at all with thee; yet out of pity, since we see thee branded with the burden of many sins and surrounded by the flames of the fire of grief, we speak once more. Go thou and do a bitter penance according to thy sins, if by any means thou mayest cross the ocean of distress." When Gardabhilla of the evil deeds heard the Wise One speak thus, his very soul grew pale, and he departed thence in misery. Dying in his wanderings, he wanders still in the ocean of rebirth.

Then the princes appointed him as Shāhi whom the Wise One chose, and themselves enjoyed dominion as his vassals. Since they were of the Śaka race, they are called Śakas, and thus began the Śaka dynasty. After a time there arose a king of Mālwā hight Vikramāditya, who overthrew the Śakas; gloriously did he reign and rule, and he established his own era. Subsequently another Śaka king displaced that dynasty, and all the vassals bowed before his lotus feet. When a hundred and thirty-five years of the Vikrama era had passed, this Śaka king established an era of his own. This explains the Śaka era. Kālakācārya re-established his sister in the pure practice of religion, and himself became the teacher of the Śakas.

KĀLAKĀCĀRYA AND INDRA

Once on a time the king of the gods (Śakra or Indra), his shining form decked with long garlands, broad of chest, his arms stiff with

splendid bracelets and armrings, earrings dancing on his cheeks, crowned with a shining diadem bright with the rays of rare gems, gazed upon the world; and he saw the Jina Sīmandharswāmī in Pūrva Videha, in the assembly of the religious. At once he bowed towards him. While he from his place listened to the Jina's teaching, the latter chose the Nigoda rule as the subject of his discourse. When he had heard all, Indra was astounded, and clutching his splendid locks, with eyes wide opened, he exclaimed: "Honoured Sir, is there in Bhāratvarṣa (India), in this Dussamā age, any one who can thus exactly expound the Nigoda?" The Jina replied: "O venerable god, there is in Bharata one Kālaka who understands the Nigoda even as I have expounded it."

When the Lightning-wielder (Śakra) heard this, he proceeded thither in the disguise of an aged Brāhmaṇa, and with respectful greeting asked the Wise One: "Honoured Sir, be good enough to expound the Nigoda rule, according to the teaching of the Jina of your day, for I long greatly to hear it." The sage replied in sweet and clear tones: "Since thou hast this curiosity, O fortunate one, listen attentively."

After hearing the exposition, Śakra (Indra), to test the monk's wisdom, enquired: "If it be allowed, pray tell me how long I should have to live if I refrained from all nourishment, taking into consideration my great age." When Kālaka reckoned up the days and months and years and centuries he found they came to two aeons, and knew by insight that this must be the Lightning-wielder. When the Wise One said accordingly: "Thou art Indra," the Brāhmaṇa resumed his own form, in fine attire and wearing dancing earrings. Bending low, touching the earth with brow, hands and knees, filled with love, he made obeisance to the lotus feet of the Wise One, saying: "Honour to thee, Lord of Sages, adorned with every virtue, who even in this degraded Dussamā age knowest the doctrine of the Jinas." Having thus honoured him, the king of gods returned to heaven. At another time the Wise One, when he knew the end of his days was come, practised the asceticism of abstaining from food, and reached the further shore.

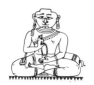

5

Explanation of Various Terms

I. It should also be observed that every Jina has his own particular complexion, cognizance, and *dīkṣā*-tree. These are as follows in the case of the four chief Jinas whose lives are illustrated in the miniatures:

Jina	Complexion	Cognizance	*Dīkṣā*-tree
Mahāvīra	Yellow	Lion (kesarī-siṃha)	Aśoka
Pārśva	Blue	Serpent (sarpa)	Dhātaki
Neminātha	Black	Conch (śaṅkha)	Vetasa
Ṛṣabha	Golden	Bull (vṛṣa)	Vaṭa (banyan)

II. A more particular account must be given of a *Samavasaraṇa*. This is, briefly, a walled enclosure prepared by Indra or the minor gods, intended for the delivery of a religious discourse by a Jina immediately after he becomes a *Kevalin*. The following description of a *samavasaraṇa* is extracted from the *Samavasaraṇa Sthavana*[1] (2) Wherever the Jinas exhibit the condition of Kevalin, in which all substances manifest themselves, there the Princes of the Air

[1]Bhandarkar, 'Jaina Iconography', *IA*, vol. XL, pp. 125-30, 153-61.

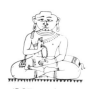

(Vāyu-kumāras) cleanse the earth for one *yojana* all around. (3) The Cloud-princes (Megha-kumāras) rain down fragrant water, the gods of the Seasons spread heaps of flowers, and the Vāna-Vyantaras make the surface of the earth variegated with ruby, gold and gems. (4) There are three ramparts: the innermost, intermediate and outermost. (The first) is constructed of gems, with the battlements of rubies, by the Vaimānakas; (the second) of gold, with the battlements of gems, by the Jyotiṣkas; (and the third) of silver, with the battlements of gold, by the Bhavanapatis. (5) In a round *Samavasaraṇa* the ramparts are 33 *dhanus* and 33 *aṅgulas* wide, 500 *dhanus* high, and 1 *krosa* 600 *dhanus* (counting both sides) distant from each other. Each rampart has four gates made of gems. (9) In the centre is a gem-studded pedestal, with four doors, three steps, and as high as the figure of the Jina, 200 *dhanus* broad and long, two and a half *krosas* high from the ground level. (10) (In the centre of the dais stands) the Aśoka tree, twelve times as high as the body of the Jina, and exceeding a *yojana* in breadth. Then (underneath) is (a pedestal called) a *devacchaṃda*, (and on it are) four lion-thrones accompanied by (four) foot-stools. (The four lion-thrones are occupied by the Jina himself on the East, and on the other sides by three reflections of the Jina, produced by the Vāna-Vyantaras). (12) At every gate the Vāna-Vyantaras put up flags, parasols, *makaras*, . . . garlands, pitchers; a triple arch (*toraṇa*), and incense vases. (14) Having entered from the East and from left to right, having sat on a seat facing the East, having placed his feet on a footstool, and having saluted the congregation (*tīrtha*), the Lord discourses on the Law. (The congregation consists of gods, men and animals) (18). . . . There are two step-wells in each corner when it is square, and one (at each gateway) when it is a round *samavasaraṇa*.

III. Another term requiring explanation is Siddha Śilā. It is merely stated in the *Kalpa Sūtra* that Mahāvīra at death became a Siddha or Mukta, i.e., one perfected or released. A description of

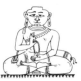

this place to which perfected souls pass, leaving their bodies here below, is given in the *Uttarādhyayana Sūtra*:

> Twelve *yojanas* above the Sarvātha (heaven) is the place Īṣatpragbhāra, which has the form of an umbrella. It is forty-five hundred thousand *yojanas* long, and as many broad, and it is somewhat more than three times as many in circumference. Its thickness is eight *yojanas*; it is greatest in the middle, and decreases towards the margin till it is thinner than the wing of a fly. This place, by nature pure, consisting of white gold, resembles in form an (inverted) open umbrella, as has been said by the best of Jinas. Above it is a pure blessed place, which is white like a conch There at the top of the world reside the blessed perfected souls, rid of all transmigration, and arrived at the excellent state of perfection.

It should be noted that the miniatures, as well as Jaina tradition, appear to identify the place described as Īṣatpragbhāra with the actual Siddha Śilā. In the miniatures, the place resembling in form an (inverted) white umbrella, is represented in section as a crescent, very thin at the margins and relatively thick in the centre. This crescent has been pointed out to me by a Jaina priest, in the actual miniatures, as the Siddha Śilā; and some of the miniatures, moreover, are thus labelled in a contemporary hand. Hüttemann is certainly mistaken in describing the crescent as that of the moon.[2]

The *Kalpa Sūtra* and the *Acārāṅga Sūtra* do not expressly mention either the Samavasaraṇa or the Siddha Śilā. But the constant representation of these places in the miniatures shows that the mention of Mahāvira's preaching (*samosarai*) the Law to gods and men, after attaining the state of a Kevalin, was understood to imply also the place of preaching, the *Samavasaraṇa*; and in the same way the statement that he became a Siddha implied that he went to the Siddha Śilā. The Īṣatpragbhāra is inhabited by fifteen varieties of Siddhas, of whom the Tīrthakara-siddhas are first.

[1]Jacobi, *Jaina Sūtras*, II, *SBE*, vol. XLV, pp. 211-13.
[2]Hüttemann, *Miniaturen zum Jinacarita*, loc. cit., p. 74.

IV. The Eight Auspicious Objects (Aṣṭamaṅgala).—Representations of the Eight Auspicious Symbols constantly recur in Jaina art.

The names of the auspicious objects are given as follows in the *Aupapātika Sūtra*; Sanskrit or English equivalents are added in brackets—(1) *Sotthiya* (svastika); (2) *Sirivaccha* (śrivatsa); (3) *Nandiyāvatta*; (4) *Vaddhamaṅaga* (powder-box); (5) *Bhaddāsana* (throne of fortune); (6) *Kalasa* (water-jar); (7) *Maccha* (fishes); and (8) *Dappaṇā* (mirror).

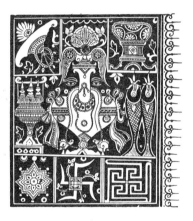
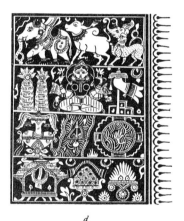

c. *d*

Illustrations from the Berlin MS. IC. 2367 of the Museum für Völkerkunde, after Hüttemann, *Miniaturen zum Jinacarita*, Baessler Archiv, 1913.
c. The Aṣṭamaṅgala, or Eight Auspicious Objects.
d. The Fourteen Dreams of the Kṣatriyāṇī Triśalā (see p. 83).

In the accompanying black and white reproduction after Hüttemann, from MS. IC. 2367 of the Berlin Museum für Völkerkunde, the water-jar forms the central object; leaves and flowers emerge from the neck, which is provided with symbolic eyes. To left and right of the water-jar are represented the powder-box and fishes. The mirror appears in the upper left hand corner, the throne on the right. Below, the *sirivaccha, sotthiya* (svastika) and *nandiyāvatta* symbols are represented in order from left to right.

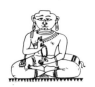

6

Cosmology

According to the Jainas, the universe is eternal. They represent it as having the form of a spindle resting on the point of a cone. Sometimes the same form is likened to a woman with arms akimbo, the junction of spindle with triangle being her waist; in corresponding diagrams, the figure of the woman thus encloses or enfolds the whole cosmos.

The summit of the spindle is formed by the Five Heavens (Vimānas) of the Anuttara gods, that of the Sarvārthasiddhas being central, and those of the Vijayas, Vaijayantas, Jayantas and Aparājitas being disposed in a horizontal plane around it. Above these is the Īṣatpragbhāra, or Paradise of the Perfected; with the exception of this Paradise, all belongs to the Saṃsāra or sphere of change, mortality and rebirth. Nevertheless, the gods of the higher heavens reside there for periods almost inconceivably long.

Below the five heavens of the Anuttara gods are the nine heavens of the Graiveyakas, arranged one above the other: the Graiveyaka and Anuttara heavens together form the upper half of the spindle.

Below them are the twelve heavens of the Kalpabhavas (sixteen according to the Digambaras), arranged one above the other,

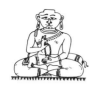

completing the lower half of the spindle. All the gods inhabiting the various heavens (vimānas) above the "waist" are called Vaimānikas.

The "waist" is formed by Mount Meru, the axis of the universe, and the lands and seas disposed about it horizontally. Here belong the Bhavanādhipati (Asuras, Nāgas, etc.), Vyantara (Rākṣasas, Kinnaras, Gandharvas, etc.), and Jyotiṣka (Suns, Moons, Planets, etc.) gods, and finally, also men.

The cone below the "waist" contains the seven hells or underworlds (Nārakas).

The geography of the worlds about Mount Meru (illustrated in figure 56) is as follows—There is a central continent around Meru, called Jambūdvīpa Bharata. Around this is the Salt Sea, separating it from the continent called Dhātukīdvīpa. Around this again is the Black Sea, separating it from the continent called Puṣkaradvīpa. The four parts of the two outer continents, and the two parts (Bharata and Airāvata) of Jambūdvīpa, constitute the "Ten Regions" or "worlds." The inner half of Puṣkaradvīpa is separated from the outer half by a range of impassable mountains, the Manuṣottara Parvata. Each continent has an elaborate system of rivers and mountains.

The southern segment of Jambū-dvīpa, called Bhāratavarṣa, is the land of India, where the twenty-four Tīrthakaras of our age (*avasarpini*) have made their appearance. It will be seen that the Bhāratavarṣa of the map, with its mountain ranges to the north, its two great rivers, and the sea round it except on the north, corresponds to the actual geography of India, with the Himalayas, Indus and Ganges, and the Indian Ocean.

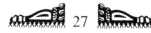

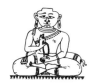

7

Aesthetics and Relationships of Jaina Painting

T he Jaina MSS., although the illuminated examples are far from common, constitute the chief exception to the general rule that Indian MSS. are not illustrated. It will be seen, however (Fig. 5), that there is no attempt at an organic relationship of text and illustration, such as always appears in Persian MSS. The Jaina miniature is simply a square or oblong picture that looks as if it had been pasted on to the page, rather than designed as a part of it. This may not arise so much from the fact that the painter and writer must have separate persons, as from the fact that Indian painting was highly developed long before the sacred books were habitually preserved in written form.

We are familiar with the striking continuity of the traditions of Buddhist painting: to give only one example, compare the White Elephant Gift (Vessantara Jātaka) as represented at Degaldoruva in Ceylon (18th century; my *Mediaeval Sinhalese Art*, frontispiece) with the same subject represented at Miran (2nd century; Stein, *Desert Cathay*, figure 147); the latter example, and indeed both,

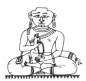

must reflect still older Indian models. Just the same must be true of the illustrations to the Lives of the Jinas: probably nothing in the composition is due to the 15th century painter, just as nothing in the text is due to the 15th century scribe. This does not mean, of course, that Jaina art has not varied in style, nor that the details of costume, architecture and manners may no largely reflect the painter's own environment, nor that there is not diversity of merit in the medieval works; it means that if we had before us Jaina paintings of the fifth century, or even earlier, we should most likely recognize in them compositions almost identical, as such, with many of those in the 15th century books, and later.

Probably the illustrations to the Kālakācārya Kathānakam have not so old an ancestry. The story itself is of later origin, and I should suppose the compositions may not go further back than the 10th century. On the whole, they are decidedly less formal and more anecdotal than those accompanying the Lives of the Jinas.

In any case, we have before us a purely Indian art derived, like Rājput and Orissa painting and the late Buddhist art of Ceylon, from old traditions; but carrying us further back in actual examples than either of these.

If we seek for definite parallels, other than such obvious resemblances as that of the figure of a seated Jina to a seated Buddha, we are reminded first of the illustrations to the oldest Nepalese palm-leaf MSS. of the Prajñāpāramitā, etc. These illustrations likewise take the form of square frames let into the text, very much as in the Jaina MSS. There are also resemblances in matters of detail: thus, the curious sloping throne (a perspective representation?) seems to be derived from the architectural canopies of the earlier art. There are also striking reminiscences of the Nepalese manner of drawing hands and feet, and general feeling for outline. Also the colouring, where, as in MS. C.A., gold is not employed, or only to an insignificant extent, recalls old Buddhist art.

The pictures are filled with characteristically Indian and ancient motifs: for example, the constant representation of *haṃsas*,

peacocks, lions and elephants, the occasional purely decorative use of the lotus to fill empty spaces (Fig. 1—not here representing a rain of flowers; cf. 18th century Sinhalese Buddhist paintings); the fondness for clouds (which have no likeness to Chinese or Persian formulas); the conventions for water; the Hindu costumes (such as the *dhotī*—note the *haṃsa* and diaper designs of the printed cotton or woven *sārīs*, etc.); the lion-thrones (*siṃhāsana*); and the bending of trees (*druma-nātir*) towards the holy man (cf. *Rāmāyaṇa*, exile of Rāma—"the trees incline their heads towards him"). The plain domed arch (Fig. 2, etc.) is of *makara toraṇa* origin; the same is doubtless true of the cusped arches (Fig. 2, r. and l.), which give no proofs of contemporary Persian influences, as they occur also in Nepalese art of the 9th century, and the upper frieze of the Viśvakarma cave temple at Elūrā, still earlier. The distinctively Persian costume of the Shāhis in Kālakācārya pictures cannot be said to prove more than an acquaintance with Persian customs.

The physical type is rather peculiar, the very sharp hooked nose and large eyes being especially striking. The sword-edged nose is also characteristic of mediaeval Nepalese bronzes and Orissan sculpture, and was admired in the most Hindu circles (in Vidyāpati, a beautiful woman's nose is compared to Garuḍa's beak); it was nevertheless a feature no less admirable in the eyes of Persians. The large eyes are of course characteristic of all Indian art; but they are here drawn in a peculiar manner, not as in Nepalese or Rājpūt paintings. The further eye is made to project from the outline of the cheek in a most extraordinary way. The prolongation of the outer corner of the eye, almost to meet the ear, is also remarkable; it corresponds to characteristic passages in Hindu literature.[1] Nevertheless, this elongation of the eye by a single fine line stretching to

Cf. *Rājataraṅgiṇī*, I, 210: "The corners of their eyes were captivating, and illuminated by a very thin line of antimony, which appeared to play the part of the stem to the ruby-lotuses of their ear-ornaments" (Stein). This description is absolutely realised in figs. 13 and 15.

the ear' (Figs. 13, 15) is not quite like anything that is familiar in other schools of Indian painting, while it very strongly recalls the drawings on 12th and 13th century Rhages pottery, and seems to me to constitute the most definite suggestion of relationship to Persian art that these Jaina miniatures afford. The use of gold leaf possibly points in the same direction.

The parallels with Rājpūt painting are naturally closer. Thus, in the Dīkṣā scene of, Mahāvīra is represented with a lion-waist and hugely developed chest; and there are many figures where it would be difficult at first sight to distinguish the representations as those of men or women. This recalls the mannerism of the large Kṛṣṇa cartoons from Jaipur.[1] We have already remarked that the representation of clouds, which appear in twelve out of the fifty-three miniatures reproduced, is anything but Persian or Chinese in manner; on the other hand, it is by no means unlike the manner of the earlier Pahārī and Rājasthānī paintings (17th century Jammu district and Rājputānā—not 18th century Kāngrā), where a narrow band of dark blue storm-cloud is constantly introduced above the high horizon. It will not be forgotten that the monsoon clouds in India are as much liked and desired as blue sky in northern Europe. Another resemblance to Rājpūt art (Jammu) appears in the strong red backgrounds (also in old Nepalese and late Sinhalese, etc.).

The architecture (Figs. 2, 5, 41, 57, etc.) resembles that of Gujarāt, where most of the miniatures must have been painted.

Indian Mughal art did not yet exist when the 15th century Jaina miniatures were being painted.

On the whole, the archaeological interest of Jaina painting exceeds its aesthetic significance. In most of the manuscripts the drawing is indeed very highly accomplished, but rather of a workshop character than deeply felt. Many of the miniatures are overcrowded with detail, the statement of fact rather than the expression of emotion. But in some cases the aesthetic values are

[1]*Ostasiatische Zeitschrift*, I, 2, fig. 1; *Indian Drawings*, II, pls. 2 and 3.

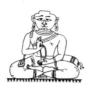

much higher. The Dīkṣā scene (Tonsure of Mahāvīra) of fig. 1, though it conforms to the usual type in most details of composition, attains to far greater dignity, and is comparable in passion with the noble passage of the *Kalpa Sūtra* which begins:"Reverence to the Saints and Blessed Ones ..." (*supra*, p. 82). That emotion is really expressed in the picture, which led the chief of the gods to descend from heaven and kneel with an offering before the Wise One. As elsewhere in Indian literature and art (the Great Renunciation of Buddha; Arjuna's Penance, etc.), we are made to feel that the Going-forth of the hero-saint is an event of cosmic and more than temporal significance. Like Blake, the poet thought that "there were listeners in other worlds than this."[1] Such examples go far to prove that there must once have existed an Indian school of Jaina painting comparable with the classic Buddhist art of Ajanṭā.

Within more secular limits, some of the Kālakācārya pictures have excellent qualities. The Shāhi upon his throne in fig. 4 and 5 is admirably designed; the vertically striped robe, as well as the pose in fig. 4, give an impression of great repose and dignity. Other pictures, such as the slaying of the magic ass (Fig. 47) are distinctly amusing, though the humour may be quite unconscious.

The diagrams are chiefly of interest as such; but there are some very well-drawn animals in the outer margins of fig. 56, especially the running tiger in the upper left hand corner.

The specimens of book-furniture afford examples of excellent craftsmanship. The embroidery of the book-covers is vigorously designed and admirably and patiently executed. The book-strings are still better; nothing could be more successful than the patterns, both geometrical and floral, while two of the examples are of special interest as having interwoven text and dates.

[1]W.B. Yeats, *Poems of William Blake*, Introduction.

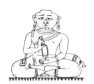

8

The Illustrated Manuscripts

The reproductions here given in fig. 1 to 53 are taken from the pages of five Jaina MSS., to which abbreviated reference is made in the descriptions facing the Plates, under the following heads—

I.O.—This is the manuscript of the *Kalpa Sūtra* (Lives of the Jinas) of Bhadrabāhu and of the *Kālakācārya Kathānakam* used by Jacobi in his editions of the texts *Abh. für die Kunde des Morgenlāndes*, VII, I, 1879, and *Zeit. der Deutsch. Morgenländischen Gesellschaft*, XXXIV, 1880 and in his translation of the *Kalpa Sūtra*.[1] The MS. is dated Vikrama Saṃvat 1484, equivalent to AD 1427, and it is at once the oldest known illuminated Indian MS. on paper, and the oldest known Indian painting on paper of any kind.

The MS. contains 46 miniatures, of which 31 belong to the *Kalpa Sūtra* and 15 to the *Kālakācārya Kathānakam*. Of these miniatures, those on ff. 3, 12, 115, 121, 129 and 144 are here reproduced in fig. 5, 9, 12, 45, 50, 51. The MS. is not merely illustrated, but also rather elaborately decorated, as may be seen from the reproduction of a whole folio in colours (Plate I). It is

[1] *SBE*, vol. XXII.

 33

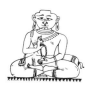

written with silver on 113 leaves, of which the ground is coloured black or red alternately. A few pages are written in gold, either on red, or on a plain ground. The borders of the pages are frequently decorated, generally with animal processions (elephants or *haṃsas*), floral branches or formal lotus-palmette frames, and occasionally with affronted *haṃsas*, antelopes, or with human figures. These borders have either a blue, vermilion, crimson or red ground. In the Library of the India Office, I am indebted to Dr. F.W. Thomas for facilities kindly granted for reproductions from this manuscript.

The following MSS., C.A. to C.F., belong to the present writer.

C.A.—Manuscript of the *Kalpa Sūtra* (98 folios) and the *Kālakācārya Kathānakam* (8 folios), measuring $9\frac{1}{2} \times 28$ cm, six lines to a page. Prākṛta, with frequent glosses: with 15 miniatures illustrating the Lives of the Jinas, and 2 miniatures illustrating the story of Kālakācārya. Not dated, but probably fifteenth century. The text is written in black ink and is decorated with plain red borders, and the central circles, etc., are rubricated. The miniatures are painted with yellow (in lieu of gold), crimson, black, green, two shades of blue, and occasional touches of bronzy gold, against a scarlet background (see figs. 1 and 2). Occasionally a pearly-white pigment is also used. The title of each picture is written in the margin of the MS. or on the picture itself. A rough diagram of each illustration also appears in the margin as a note to remind the painter of the required subject; possibly the painter was unable to read, and made these spirited marginal notes, according to the instructions of the writer of the MS., or of a reader who went over it with him.

The miniatures in this MS. are remarkable for the accomplishment of the fine brushwork (see figs. 1, 2, 6, 7, etc.). The dīkṣā scene of fig. 1 is especially noteworthy for its simplicity and dignity.

C.B.—Manuscript of the *Kalpa Sūtra* (72 folios) and *Kālakasūri Kathānakam* (5 folios), measuring 11×30 cm, nine lines to a page. Prākṛta, with 28 miniatures illustrating the Lives of the Jinas and 6

miniatures illustrating the story of Kālakācārya. Dated Saṃvat 1554 (AD 1497). Text in black ink with red borders and rubricated central circles, etc.; first page with a blue pattern border. Painted with crimson, black, blue, white and scarlet (forming the background of the finished work) on a gold ground (left uncoloured to form the figures, etc.). The miniatures are not labelled. The marginal diagrams are extremely faint.

C.C.—Manuscript of the *Kalpa Sūtra* (107 folios), measuring 10.5 × 25.5 cm, seven lines to a page, with 24 minatures illustrating the Lives of the Jinas. Prākṛta. No date, but probably 17th century. Concludes with the colophon "Iti Gherāvali sūtram" erased. The colouring is similar to that of C.B., except that the background is bright blue in place of scarlet. The illustrations have marginal legends, but no marginal diagrams. Inferior paper. The execution is generally inferior to that of C.A. and C.B., but a number of subjects which appear in C.C. are not given elsewhere.

C.D.—Manuscript of the *Kālakācārya Kathā*, 9 folios measuring 11 × 26 cm, nine lines to a page, with six miniatures illustrating the story of Kālakācārya. Prākṛta. No date, but of fine quality and probably early fifteenth century. Miniatures coloured as in C.B. Text bordered with red and central circles rubricated.

The two following are mentioned for comparison, but no miniatures are reproduced:

C.E.—Manuscript of the *Ratan Sāra* (Life of Pārśvanātha, etc.), 21 folios measuring $10\frac{1}{2}$ × 26 cm, thirteen lines to a page, text in black ink with red and yellow borders, and rubricated central circles. Dated Saṃvat 1633 (AD 1566). Prākṛta. Illustrated with four crude miniatures, of which one occupies a full page, viz., a woman, with the legend "Sri Pārśvanātha bhāryā prabhāvatī mūrtti jāṇavī."

C.F.—A manuscript of 12 folios, measuring 16 × 32 cm, sixteen lines to a page, with a picture of a Jina on each side of each folio. The drawing is quite perfunctory. No date, but probably eighteenth century.

The following MSS. are in the British Museum:

Ms. Or. 5,149—Manuscript of the *Kalpa Sūtra*, 80 folios, nine lines to a page. Has 25 miniatures illustrating the Lives of the Jinas. Text in black ink, with plain borders, central circles, etc., in red. Prākṛta, dated Saṃvat 1521 (AD 1464).

MS. Or. 5, 257—Manuscript of the *Uttarādhyayana*, 16th-17th century, with one miniature.

MS. Or. Add. 26,374.—Manuscript of the *Kṣetra-samāsa laghu-prakaraṇaṃ*, a system of geography according to the Jainas. Prākṛta, with Gujarātī commentary. With numerous pictures and diagrams. Dated Saṃvat 1826 (AD 1769).

The whole of folio 16 (obverse) is here reproduced in fig. 55. The following MSS. are mentioned by Hüttemann:

I.C. 2, 367.—The *Kalpa Sūtra*. An MS. in the Berlin Museum für Völkerkunde. Studied by Dr. Hüttemann (*Miniaturen zum Jina-carita*, loc. cit.). The MS. has 24 miniatures illustrating the Lives of the Jinas, of which Dr. Hüttemann reproduces 14 (two in colours); four of his figures are here copied in the text figures *a* to *d*.

Ms. Or. 799—The *Kalpa Sūtra* ;"mit zahlreichen, sehr schönen ...miniaturen," in the Royal Library, Berlin. Mentioned by Dr. Hüttemann, loc. cit.

9

Description of the Figures

The reproductions (Figs. 1-5) are not in the sequential order of the history, but are chosen as typical examples of colour. Figs. 1-4 size of original; fig. 5 slightly reduced.

Fig. 1. Tonsure of Mahāvīra (his initiation as a monk). On the left, Indra seated, four-armed, two hands holding a divine garment, one holding a goad (attribute of Indra), the other receiving from Mahāvīra his cast-off royal robes; below, the elephant Airāvata, the *vāhana* of Indra. On the right Mahāvīra, wearing a waist cloth only, seated beneath an Aśoka tree which is slightly inclined towards him, is plucking out his long locks. The foreground represents a hilly park, with Aśoka trees. The horizon is very high; the sky is filled with heavy monsoon clouds. A conventional lotus occupies a space between the figures and the horizon. Cf. fig. 26; Hüttemann, fig. 9 (here text fig. *b*); B.M. MS. Or. 5,149, folio 37, labelled "*Mahāvīra dīkṣā*; MS I.O. folio 50; and MS. C.C., folio 30, labelled "*Dīkṣā.*"

M.S. C.A., folio 49, labelled "*Mahāviraloca.*"

Fig. 2. Pārśvanātha. The Jina enthroned; his crown is surmounted by five snake hoods. The throne is supported by two

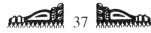

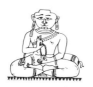

elephants and two lions, and contained in a mandir, cells of which are occupied by worshippers. The upper arch contains elephants; the upper corners two *haṃsas*. The upper central part of the throne, just below the Jina's feet, shows the *nāga*, which is the cognizance of Pārśvanātha. Cf. fig. 32, 57.

MS. C.A., folio 59.

Figure 3. Mahāvīra as the Perfected One, enthroned above the heavens, in Īṣatpragbhāra. The inverted crescent represents the Siddha Śilā, or Rock of the Perfected. Aśoka trees on either hand lean towards the Jina. His lion-cognizance appears on the front of the throne, which is surmounted by an umbrella. The landscape shows mountains below and a cloudy sky. Cf. figure 29; Hüttemann, fig. 9; B.M. MS. Or. 5,149, folio 37; and MS.C.B., folio 38, labelled "*Mukti Śilā.*"

Figure 4. Kālakācārya conversing with the Śaka Shāhi. The latter sits on a lion throne, holding a flower in his left hand, while the monk faces him with folded palms. The Shāhi seems to be speaking and the monk listening.

MS. C.D., folio 2.

Figure 5. Folio 129 of the MS. I.O., with decorated text, and miniature representing Kālakācārya instructing the Śaka Shāhi. As in figure 4, but the monk is speaking and the Shāhi listening.

(All the figs. (6-11) of the size original)

Figure 6. The Jina (Mahāvīra) enthroned; he wears royal ornaments and holds a begging bowl.

MS. C.A., folio 1; labelled "*Mahāvīra.*"

Figure 7. The Jina (Mahāvīra) as Guru (preaching), wearing a monk's robes; the right hand raised in *vitarka mudrā*, and holding a rosary. The Jina is seated in a shrine of simple construction; above it are two parrots. The sky is filled with heavy clouds. Cf. fig.8.

MS. C.A., folio 2; labelled "*Guru.*"

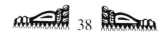

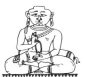

Figure 8. The Jina (Mahāvīra) as Guru (preaching), wearing monk's robes; the right hand raised in *vitarka mudrā*, and holding a rosary. On either side of the shrine are worshippers in niches surmounted by affronted birds. In four compartments above and four below, are represented the Aṣṭamaṅgala, or eight auspicious objects, viz. (in order from left to right, above): *sirivaccha, vaddhamaṇaga* (powder-box), *bhaddāsaṇa* (throne), *dappaṇā* (mirror); (and below) the *nandiyāvatta, sotthiya* (swastika), *kalasa* (water-jar), and *maccha* (fishes). In this miniature two subjects, the Guru and the Aṣṭamaṅgala, are combined more often these form the subject of two separate illustrations. Cf. Hüttemann, fig. 1 ; MS. I.O., folio 2 ; and B.M. MS. Or. 5,149, folio 2.

MS.C.B., folio 2 ; labelled "*Aṣṭamaṅgalāka.*"

Figure 9. Devānandā's Dreams. Below, Devānandā reclining on a couch. Above, twelve dreams (out of fourteen) in the following order : garlands, Padmāvatī, lion, bull, elephant, palanquin, river, lotus pond, water-jar, banner, and the sun and moon. Cf. Hüttemann, fig. A ; MS. C.B.; and MS. C.C., folio 4.

M.S.I.O., folio 3.

Figure 10. The Court of Indra. Left, Indra enthroned, four-handed, holding goad and trident, some other object on one left hand, and with the right hand raised. Before him are three courtiers, *devas* resembling himself. Cf. MS.C.C., folio 8, labelled "*Indraya sabhā.*"

M.S. C.B., folio 5; labelled "*Indra.*"

Figure 11. Indra, descended from his throne, bows to Mahāvīra. He holds the goad in one left hand, an offering in another, and two other hands are joined in reverence. The curious throne, apparently of the type of a mandir built askew, is well seen. Observe the *haṃsa* and check patterns of a *dhotīs* worn in this and the last picture. Cf. B.M. MS. 02,5149, folio 6, labelled "*Namokṣaṇam*"; MS. I.O., figure 9; and MS. C.C., folio 10, labelled "*Indra namokṣaṇam bhaṇai.*

MS. C.B., folio 6; labelled "*Indra namokṣaṇam.*"

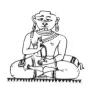

(All the figures (12-17) of the size of the original)

Figure 12. Hariṇegamesi receiving the commands of Indra. Indra is enthroned; Hariṇegamesi stands with raised joined hands in an attitude of respect and attention. Indra is four-handed, and holds the goad and trident. Hariṇegamesi has the head of an antelope joined to the body of a man.

M.S. I.O., folio 12.

Figure 13. Hariṇegamesi removing the embryo from the womb of the Brāhmaṇī Devānandā. Devānandā reclines on a cushioned couch, below which are seen a ewer and a dish of *pān supārī*. The embryo is represented as a ball. Above the roof are heavy clouds. Cf. B.M. MS. Or. 5,149, folio 10; and MS. C.B., folio 10, labelled "*Garbhāpahār Hariṇegameṣī.*" MS..C.C. shows this subject and the next in one miniature, labelled "*Garbhāpahār garbha sacaraṇa.*"

MS. C.A., folio 15; labelled "…*Hariṇegamesī.*"

Figure 14. Hariṇegamesi bringing the embryo to the Kṣatriyāṇī Triśalā. Generally similar to the last, but the embryo is more realistically represented, as in Hüttemann's figure 3. Cf. also B.M. MS. Or. 4149, folio 11, labelled "*Garbha sacaraṇa.*"

MS. C.B., folio 11; "*Hariṇegameṣī garbha-prakṣepa.*"

Figure 15. The Kṣatriyāṇī Triśalā attended by a maid-servant. The lady reclines on a couch, while the maid plies a fly-whisk (*cāmara*).

MS. C.B., folio 12; labelled "*Rāṇī Triśalā.*"

Figure16. The Fourteen Dreams of the Kṣatriyāṇī Triśalā, viz.—First row : elephant, bull, lion. Second row : Padmāvatī, garlands, sun and moon, banner. Third row: water-jar, lotus tank, river. Fourth row : palanquin, heap of jewels, fire. It is noteworthy that the "lion" (*siha*) of the texts is here, as in Hüttemann's figure 2, represented by a *gaja-siṃha* or mythical elephant-lion. [A true lion is represented in the next figure (1.7) from the MS. C.A., folio 34.] The water-jar is provided with symbolic eyes. The tank is walled, with four gates or *ghāts*, and a lotus in the middle. A sailing vessel

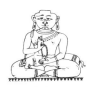

and fishes are seen in the river, and flowers are growing along its margin. Water is represented by intersecting straight lines which are really parts of concentric curves according to the usual formula. Cf. Hüttemann, figure 2; B.M. MS. Or. 5,149, folio 13, labelled "*Svapna 14 lahar*"; and MS. C.C., folio 21, labelled "*Triśala svapna 14.*"

MS. C.B., folio 13; labelled "*Cauda satraṇā.*"

Figure 17. The Fourteen Dreams of the Kṣatriyāṇī Triśalā, as above, but with differences of detail. The lion is a true lion. The tank is not walled. There is no ship on the river. The water is represented by intersecting segments of concentric circles, according to the most frequent Indian convention (cf. figures 30 and 31). Cf. B.M.M.S. Or. 5, 149 folio 13 ; MS. I. O., folio 21 ; and Hüttemann, fig.2.

MS. C.A., folio 34; labelled "*14 satraṇām.*"

(All the figures (18-23) are slightly reduced)

Figure 18. Toilet of Siddhārtha. A maid-servant is dressing his hair, after the bath. Cf. MS. C.C., folio 35.

MS. C.B, folio 21.

Figure 19. Darbar of Siddhārtha. He is enthroned, to the left. On the right, three kneeling soldiers.

MS. C.B., folio 22; labelled "*Rājā-sabhā.*"

Figure 20. The Kṣatriyāṇī Triśala reclining. She is probably listening to the interpretation of the dreams.

M.S. C.A., folio 36; labelled "*Rājā-rūpa*" (probably for "*Rāṇī-rūpa*").

Figure 21. The interpretation of the dreams. On the left, Siddhārtha seated enthroned, beneath a royal umbrella; on the left, a Brāhmaṇa reading from a book. Cf. Hüttemann, fig. 5; MS. C.B., ff. 23, 24; and B.M. MS. Or 5, 149, folio 24, labelled "*Rājā rāṇī sapna pāthaka.*

MS. C.A. 36; labelled "*Svapna-lakṣaṇa pāṭhakāḥ.*

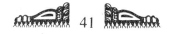

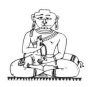

Figure 22. Birth of Mahāvīra. Triśalā, reclining, holds the child in her arm, and is fanned by a maid-servant, using a fly-whisk (*cāmara*). Cf. Hüttemann, fig. 6; B.M. MS. Or. 5, 149, folio 29, labelled "*Mahāvira janma*"; MS. C.C., folio 48, labelled "*Vīra janma*"; and MS. I.O., folio 40.

MS. C.B., folio 28; labelled "*Janma*".

Figure 23. The Birthday Festival, or "Apotheosis". Mahāvīra seated on his mother's (?) lap, while deities on either side offer water of lustration in golden ewers. Two bulls with waving tails descend from heaven towards Triśalā. The figures are all floating in mid-air above the mountains, but the bulls are descending a sort of golden staircase. Cf. Hüttemann, fig. 7; B.M. MS. Or, folio 30; and MS. I.O., folio 42.

MS. C.B., folio 29; labelled "*Janmābhiṣekha*".

(All the figures (24-29) are of the size of the originals)

Figure 24. Mahāvīra distributes his wealth. He is seated on a throne before a table covered with gems, which he is presenting to three Brāhmaṇas. Cf. B.M. MS. Or. 5,149, folio 35, labelled "*Mahāvira dāna*"; and MS. C.C., folio 56, labelled "*Vīra dāna.*"

MS. C.B., folio 32; labelled "*Samvatsarī dāna.*"

Figure 25. The Indifference of Mahāvīra. He stands, attended by two deities and two antelopes, and is unmoved, though a serpent, a scorpion, a lion and a dog are attacking him. Cf. Hüttemann, fig. 10, where there are two serpents, and the dog is replaced by a woman cooking (representing pleasure). This subject is not given in MSS. C.A. and C.B., nor I.O.

MS. C.C., folio 60; labelled "*Vīra upasarga*".

Figure 26. Tonsure of Mahāvīra. On left, Mahāvīra seated beneath an Aśoka tree, plucks out his hair. The tree bends over him (called *drumā-natir*, a mark of gods and *arhats*), acknowledging his greatness. On the right, Indra, kneeling beneath a royal umbrella, offers a divine robe; one hand holds the trident. The clouds above,

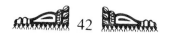

42

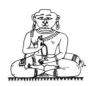

usually blue, are here green. Cf. Hüttemann, fig. 9 (here text fig. *b*); B.M. MS. Or. 5,149, folio 37; MS. I.O., folio 50; MS. C.C., folio 30; and figure 1.

MS. C.B., folio 34; labelled "*Dīkṣā*".

Figure 27. *Samavasaraṇa* of Mahāvīra. A triple walled enclosure with four gates, as described in text, *supra*. Mahāvīra seated in centre. A step-well and animals are represented in each corner. Cf. figure 28; B.M. MS. Or. 5,149, folio 38, labelled "*Mahāvīra jñāna*"; MS. I.O., folio 53; and MS. C.C., folio 64, labelled "*Jñāna*."

MS. C.B., folio 37; labelled "*Jñāna samosaraṇa*."

Figure 28. *Samavasaraṇa* of Mahāvīra. As figure 27.

MS. C.A., folio 53; labelled "*Mahāvīra samosaraṇa*."

Figure 29. Mahāvīra as the Perfected One, enthroned above the heavens in Īṣatpragbhāra. The inverted crescent represents the Siddha Śilā, or Rock of the Perfect, as described in the text, *supra*. Heavy monsoon clouds above, and mountains below. The body of the Jina is bright yellow; he is supported by *haṃsas* and Siddhas on either side. Cf. figure 3; Hüttemann, figure 9; B.M. MS. Or. 5,149, folio 39, labelled "*M. nivaṇi*"; MS. I.O., folio 55; and MS. C.C., folio 66, labelled "*Vīra muktī*".

MS. C.A., folio 55; labelled "*Siddhi*."

(All figures (30-35) are of the size of the originals)

Figure 30. Above, Pārśvanātha in Īṣatpragbhāra, enthroned above the Siddha Śilā; his head is surmounted by five cobra hoods. Two *dhātaki* trees rise from the peaks below, bending toward the Jina. Cf. MS. I.O., folio 66. Below, Pārśvanātha protected by the *nāga* Dharanendra. The Jina stands in a sea or lake, and is worshipped by a *yakṣa* and *yakṣiṇī*. Cf. figure 31 and B.M. MS. Or. 5,149, folio 46.

MS. C.B., folio 44.

Figure 31. Pārśvanātha sheltered by the *nāga* Dharanendra. The Jina stands in a sea or lake, supported by a *yakṣa*, and sheltered by

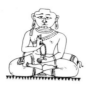

the *nāga*, whose hoods rise above his head, and tail lies in the water. Cf. B.M. MS. Or. 5,149, folio 46, labelled "*Pā. upasarga*".

MS. C.C., folio 75; labelled *Pārśva upasargra.*"

Figure 32. Pārśvanātha enthroned. The throne is supported by elephants and lions. The Jina's head is surmounted by five cobra hoods and an umbrella. Three worshippers on either side. Cf. Hüttemann, figure 11.

MS. C.C., folio 77; labelled "*Pārśva pratimâ.*"

Figure 33. Above, a king worshipping the śaṅkha, a symbol of Neminātha. Below, a subject not identified; possibly the Jina snatching a sceptre from Indra.

MS. C.C., folio 79; labelled "*Śaṅkha pūriu hari-hāro liu.*"

Figure 34. Neminātha enthroned. The throne, etc., as in figure 2. The figure of the Jina dark blue; below him, in front of the throne, the śaṅkha cognizance; observe the śaṅkha also indicated beneath the sketch figure in margin. The Jina holds a begging bowl. Cf. MS. C.C. 78, labelled "*Nemi pratimā.*"

MS. C.A., folio 66; labelled "*Niminātha.*"

Figure 35. Ādinātha enthroned. The throne, etc., as in figure 2, 34. The figure of the Jina yellow; below him, in front of the throne, the bull cognizance, and the same in the marginal sketch. Cf. MS. C.C., folio 88, labelled "*Adinātha pratima.*"

MS. C.A., folio 72; labelled "*Śrī Ādinātha.*"

(All figures (36-41) are of the size of the originals)

Figure 36. Episodes in the life of Neminātha.

MS. C.C., folio 80; labelled "*Nemi pasuvāda.*"

Figure 37. Prince (?) riding on an elephant, beneath a large royal umbrella.

MS. C.C., folio 89; labelled "*Hasti-mūrtikā umbha.*"

Figure 38. The twenty Tirthakaras between Ṛṣabha and Neminātha. MS. C.C., ff. 63 and 64, show the twenty Tīrthakaras in two groups of ten, each labelled "*Tīrthankara IO.*"

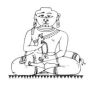

MS. C.B., folio 48.

Figure 39. The eleven *gaṇadharas* of Mahāvīra; in the centre of the third row, the centre space is occupied by an Oṃkāra figure with a lotus. Cf. MS. C.C., folio 95, labelled "*Gaṇadhara II*," where the Oṃkāra figure is replaced by the Hrīṃkāra.

MS. C.B., folio 54; labelled "*Gaṇadhara II*."

Figure 40. Four episodes in the life of Ṛṣabha; viz., *janma, mukti-śilā, dīkṣā* and *samavasaraṇa*.

MS. C.B., folio 47; no label.

Figure 41. Ṛṣabha enthroned in a mandir, with worshippers. His bull cognizance appears on the front of the throne. A parrot and a monkey are seen on the *śikhara*, which is crowned by a banner.

MS. C.B., folio 72, the last page of the *Kalpa Sūtra* proper, with colophon; the reverse of the same leaf begins the *Kālakācārya Kathānakam*, with a picture similar to that of figure 45. No label.

(All the figures (42-47) are of the size of the originals)

Figure 42. Balamittra (nephew of Kālakācārya) preaching to a lion; other monks below. I cannot explain this figure; it is, no doubt, a legend connected with the third section of the story of Kālakācārya, but no lion is referred to in the text translated by Jacobi.

MS. C.D., folio 6; labelled "*Balamittra bhāṇae*."

Figure 43. Darbar of King Gardabhilla. The king is seated on a throne, beneath a royal umbrella; before him are his general and army, and cavalry. Cf. MS. C.B., folio 84.

MS. C.A., folio 100; labelled "*Gardabhilla*."

Figure 44. Kālakācārya instructing the Śaka prince. The latter sits on a lion throne, surmounted by two umbrellas; before him are his bow and arrow hung on a tripod, and two courtiers kneel above. Note the Persian costumes, contrasting with the purely Hindu dress of Gardabhilla in figure 43. On the right, Kālakācārya is seated on a cushion, reading from a book. Heavy clouds above. Cf. figure 49 (MS. I.O., folio 121).

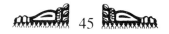

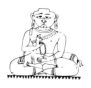

MS. C.A., folio 100; labelled "*Śakarāya*."

Figure 45. Above, Kālakācārya instructing the Shāhi (here an outdoor scene, with hills, trees and clouds). Below, the Shāhi setting out with the army, for Hindustān. On the left, a floral border.

MS. I.O., folio 115.

Figure 46. Above, Kālakācārya instructing the Shāhi, as in figure 44. Below, Kālakācārya changing the potter's stuff to gold; he is shaking a powder over the burning kiln, the Shāhi on horseback looking on.

MS. C.B., folio 74.

Figure 47. Kālakācārya's archers slaying the magic ass. Gardabhilla, within the walls of a fortified city, seated before a fire, performing magical rites, creating the magic ass which stands in the gateway. Above, also within the city, Sarasvatī, within the royal zenana. Below, horses in the royal stables. Outside the city walls, archers of the Shāhi's army, with Kālakācārya himself on horseback, firing arrows into the ass's mouth. A triangle of cloud in the upper right hand corner.

MS. C.B., folio 75.

(The reproductions figures (48-53) are of the size of the originals).

Figure 48. Above, Gardabhilla is brought a prisoner before Kālakācārya; below, Kālakācārya goes to the zenana to bring away his sister.

MS. C.B., folio 76.

Figure 49. Kālakācārya instructing the Shāhi, as in figures 44 and 46. *q.v.*

MS. I.O., folio 49.

Figure 50. Kālakācārya enthroned, holding a book in his right hand, of which also the thumb and first finger are joined in *vitarka mudrā*, with his left hand touches the head of a kneeling monk or nun (probably Sarasvatī, on the occasion of re-admission to the sisterhood), who touches his feet. On the right, above the kneeling

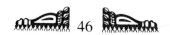

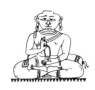

figure, appears a sort of table, on which rests a book covered with flowers. A similar table appears in figures 48, 51 and 53, also figure 32. Its construction resembles that of the modern camp-stool. [It is of considerable interest to see such tables represented in use, as they correspond closely with the Sinhalese *daṇḍāsana*, of which an illustration appears in my *Mediaeval Sinhalese Art*, plate X, fig. 1. I had never seen one of these in use, though I knew them as of monastic origin, and was informed that they were used as book-tables.]

MS. I.O., folio 144.

Figure 51. Above, Indra disguised as an aged Brāhmaṇa, visits Kālakācārya; below, Indra assumes his proper form, and takes leave of Kālakācārya. [See the story related above, Section IV].

MS. C.D., folio 9.

Figure 52. A king and queen dancing, possibly an erotic subject. This king is shooting an arrow at a parrot (the *vāhana* of Kāmadeva) on a tree beneath which the queen is dancing.

MS. C.C., folio 100; labelled "*Nṛtya*"

Figure 53. The Education of Baḍrasvāmī (? Baḍrabāhu, author of the *Kalpa Sūtra*). Above, apparently dedication of the child to the order; below, the child in a swing.

MS. C.C., folio 98; labelled "*Baḍrasvāmi pālanu.*"

The last two figures, the subjects of which I cannot properly explain, occur only in my MS. C.C.

Figure 54. Diagram of a *Samavasaraṇa* drawn in black, yellow and red on buff paper. [See description above, Section V.] The diagram is inscribed with details of dimensions, and indicates the position occupied by the various deities, men and animals. Two step-wells are represented in each corner, although the *samavasaraṇa* is round. The diagram is dated in the top right hand corner, Saṃvat 1680, equivalent to AD 1623 Size of original diagram, 33 × 27 cm. Collection of the author.

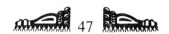

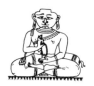

(Figures (55-56) are reduced)

Figure 55. Page of a Jaina MS., with miniature apparently representing the Paṇḍaga and Somanasa forest. The latter forms a girdle round Mount Meru at its base, and differs from the Paṇḍaga-vaṇa in not being mountainous; it occupies the curved wooded area at the lowest part of the picture. The rocky Paṇḍaga-vaṇa is represented by the six tree-clad arms of the mountain. The temple above is the shrine of a Tīrthakara on the summit of Meru. (I am indebted to the kindness of Dr. L.D. Barnett, of the British Museum, for the above reading).

B.M. MS. Or. Add. 26, 374, folio 16.

Figure 56. Cosmic diagram showing the lands and seas around Mount Meru. [See above, Section VI.] Bhārata-varṣa (India) forms the lower segment of the central circle.

From a large diagram painted on cotton cloth. Collection of the author.

(Figures (57-58) are reduced)

Figure 57. Śrī Pārśvanātha. The central panel shows the Jina enthroned in a mandir, of which the *śikhara*, adorned with a flag and approached by a Siddha, occupies the square immediately above. Right and left of Pārśvanātha are narrow panels occupied by the *nāga* Dharaṇendra and the *yakṣiṇī* Padmāvatī. On the extreme left, Indra; on the extreme right, Padmāvatī. Above, on the left, the *Samavasaraṇa* of Pārśvanātha [note the Jina with three reflections of himself, occupying the centre, as described in the text, Section V]; on the right, the "Pañca-Pad" [above, five Oṃkāra ideographs, then five seated Siddhas (?) above the crescent of the Siddha Śilā (?)]. Below, on the left, Suddharma Svāmī (?); on the right, Gotama Svāmī. The lower central panel I cannot explain.

From a painting on cotton cloth, probably 16th century. Size of original, 30 cm square. Colours: vermilion (background), crimson, pink, blue, green, black, white and gold (chiefly the square of gold

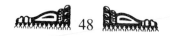

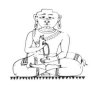

leaf over which the central figure of the Jina is drawn). The cloth has been primed before painting. Spots of sandal paste upon the chief figures show that the picture has been used as an object of worship. Collection of the author.

Figure 58. MS. cover, embroidered with the Fourteen Dreams of the Mother of Mahāvīra. The subjects are as follows: To right of centre, large panel, Padmāvatī; next column, above, the bull; centre, two garlands; below, the sun; extreme right, above, the elephant; centre, the lion; below, moon and stars; left of Padmāvatī, above, the flag; below, the ocean (river) of milk; next column, above, the golden vase; below, the heavenly mansion. The remaining four subjects are not recognizable.

The embroidery is executed in silk on cotton. The colours are crimson, orange, blue, green, cream and black. The narrow border is cross-stitch, as in figure 63. The remainder of the work is couched, except the inconspicuous cream outlining in chain-stitch. Size of original, 30 × 13 cm. Probably 16th century. Collection of the author.

(The figures (59-63) are reduced)

Figure 59. MS. cover, embroidered with the Fourteen Dreams of the Mother of Mahāvīra, and the Eight Auspicious Objects (Aṣṭamaṅgalāka). The cover consists of two parts hinged together, and is designed to keep together the loose leaves of any MS. resting on the inside of the larger part. The dreams are represented on this larger flap: Padmāvatī occupies the central squares of the two lower rows. The gold vase is on her proper left. The first four squares of the upper row contain respectively the elephant, bull, lion and two garlands; the two squares on Padmāvatī's proper right contain the flag and throne. The remaining subjects are no longer recognizable.

The narrow portion of the cover contains the Aṣṭamaṅgalāka, which are upside down in the reproduction. The subjects are, from left to right: *nandiyāvartta*, fishes, golden vase, throne, mirror,

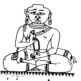

sirivaccha, powder-box, and *sotthiya* (swastika).

The needlework is of silver thread on red wool; a very little green and purple silk is also used. The silver thread is partly chain stitch, partly couched.

Size of original, $27\frac{1}{2} \times 20$ cm. Probably 16th century. Collection of the author.

Figure 60. Portion of an embroidered MS.-cover. Silk on cotton canvas, chevron design. Colours: crimson, yellow, orange (two shades), blue, green and white $\times \frac{6}{7}$.

Figure 61. Portion of an embroidered handkerchief, for wrapping MSS. Silk on cotton canvas, in striped lozenges; colours as the last. Nearly $\frac{1}{1}$.

Figure 62. Portion of an embroidered MS.-cover, silk on brown cotton canvas, in lozenges, crimson, orange, green, yellow and white in dark blue framework. Nearly $\frac{1}{1}$.

Figure 63. Portion of an embroidered MS. cover, silk cross-stitch on brownish cotton canvas. Colours: blue, orange, green, yellow, cream and black $\times \frac{4}{5}$.

The originals of figures 60-63 are all most likely 16th century. Collection of the author.

Figure 64. Book-braid (*kora*), for typing up MSS. Cotton braid, blue and white, bordered with brownish red. The text reads as follows:

Main samujhyō niradhāra yah jaga kāvōkāva-so
Ekai-rūpa apāra pratibimbata lakhiyata jagata
Sambata rasa-rasa-muni-mahi usiyārapurā subha khēta
Kōra kari Bhagatū Jati Pūjya Nārāyaṇa hēta.1766

i.e., I clearly understood, after examination of whose and from whom is this world,

God has but one transcendent form, the world is manifest as (His) reflection.

In Saṃvat 1766, in the holy land of Usiyārapur

Bhagat Yati made this *kora* in honour of the Reverend Nārāyaṇa.

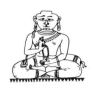

The first two lines are in the metre 6, 4, 1 : 6, 4, 3; the next two lines 6, 4, 3 : 6, 4, 1. In the third line, the metre (6, 4, 3 : 6, 4, 1) requires omission of the syllable "ār" in Usiyārapura.

Saṃvat 1766 = AD 1709. Width of the braid, 2.1 cm. Collection of the author.

Figure 65. Book-braid (*kora*), for typing up MSS. Cotton braid, blue and white, bordered with brownish red. The text reads as follows:-

Pāpa-pantha pariharahi dharahi subha pantha paga
Para-upagāra nimitta bakhāṇahi mōkhi-maga
Sadā avaṃcchata-citta ju tāraṇa-taraṇa-jaga
Aisē gura-kōṅ seva- ta bhāgahi karma ṭhaga. 1766
i.e. (A guru) who forsakes the path of sin, and sets his foot on the holy path,
Who tells the way of salvation for other's good,
Whose mind is ever of guarded mind (*avaṃcchata?*), who is a saviour from the world,
Such a guru serving, the thief of merit runs away.

These lines are in the metre 6, 4, 2 : (3, 2), 2. 1766 = AD 1709
[I am greatly indebted to the kindness of Dr. Sir G.A. Grierson, who sent me the reading and translation of the texts reproduced in figures 64 and 65].

Figure 66. Book-braid (*kora*), for typing up MSS. Cotton braid, blue and white, bordered with brownish red. No text. Probably 18th century.

The three braids (figs. 64-66) are in the collection of the author.

For Gotama Swami see Jacobi, H., 'Kalpasutra', *ZDMG*, Introduction, p.1.
The Pañcapuruṣa are referred to in Blumrdt, *Cat. Hind... Ins. in B. M. S.V. no.*

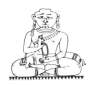

Index

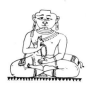

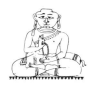

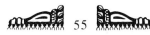

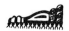 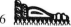

Illustrations

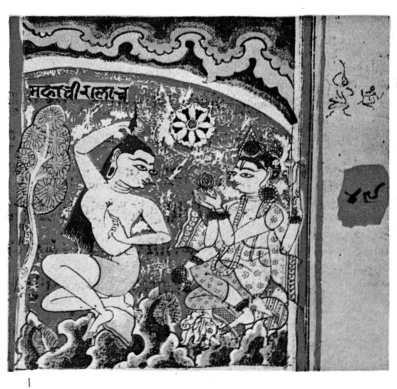

1

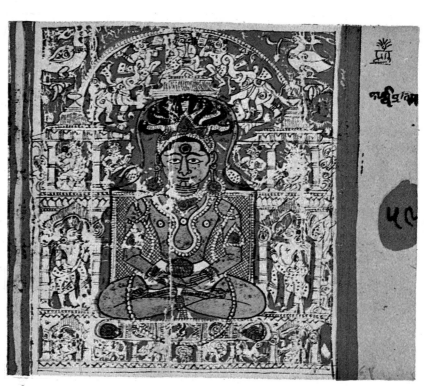

2

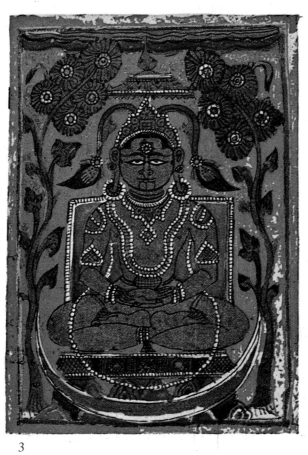

3

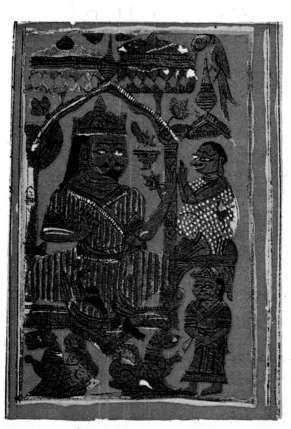

4

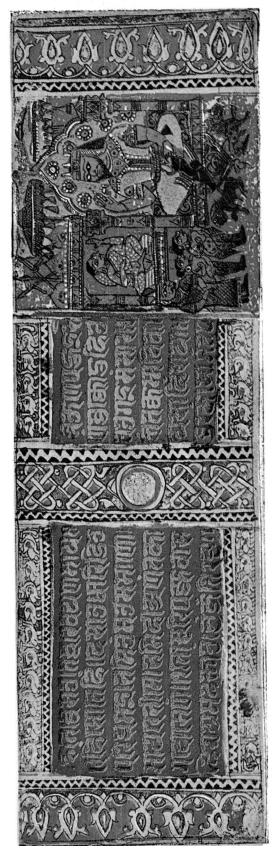

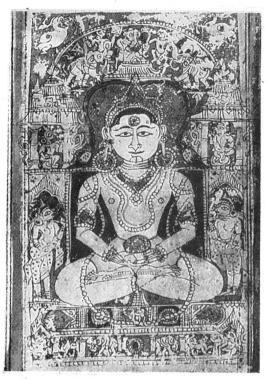

6

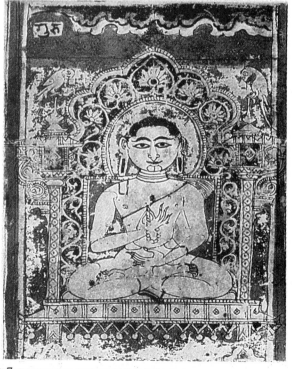

7

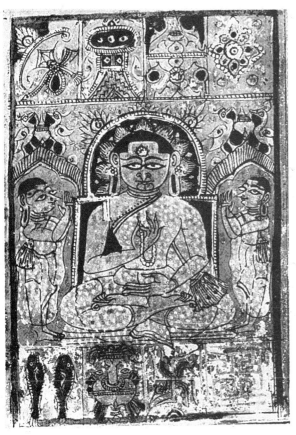

8

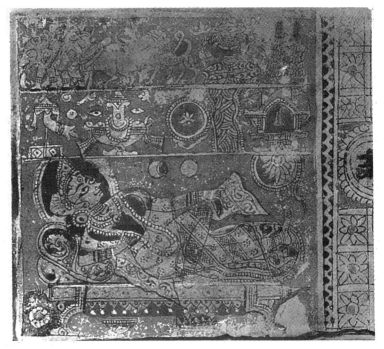

9

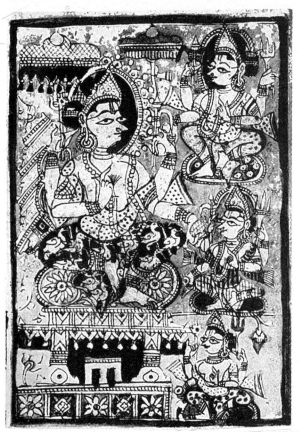

10

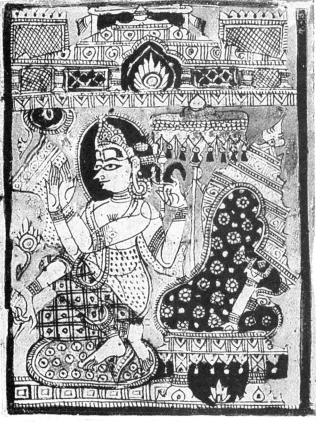

11

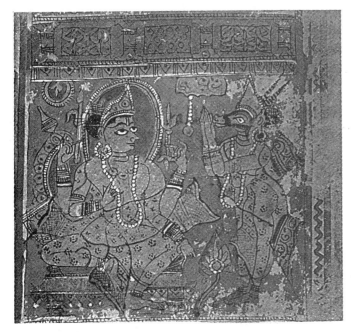

12

13

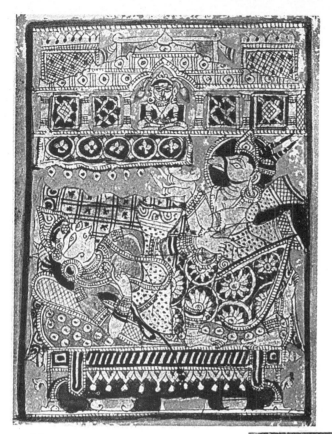

14

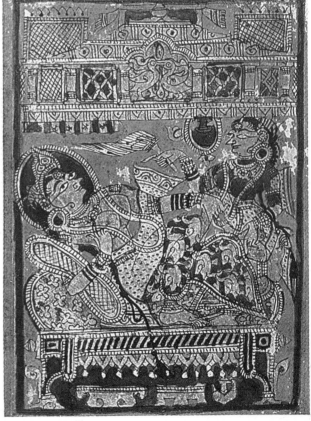

15

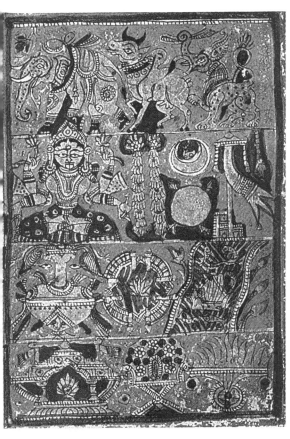

16

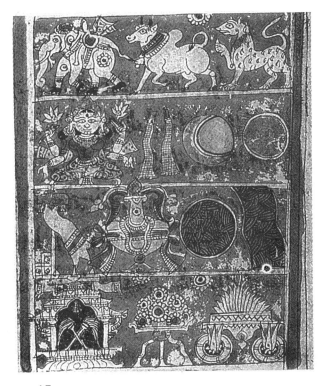

17

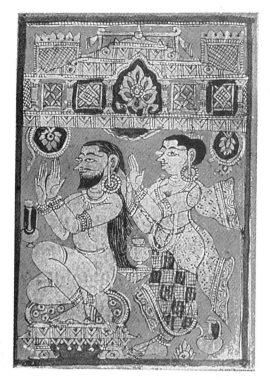

18

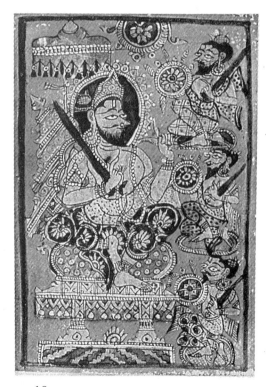

19

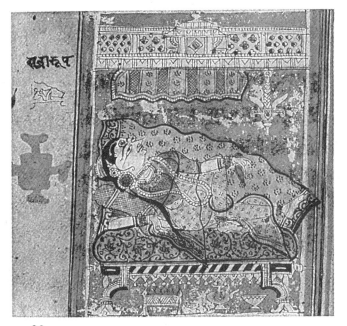

20

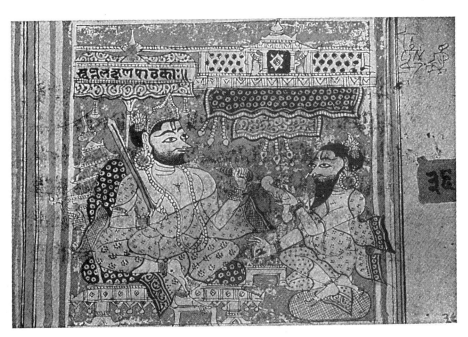

21

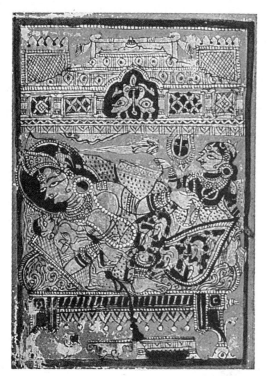

22

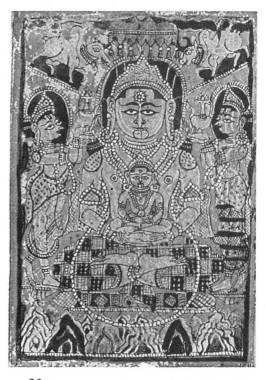

23

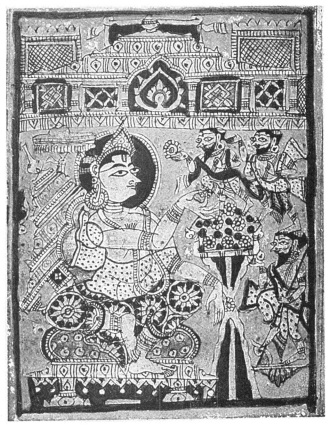

24

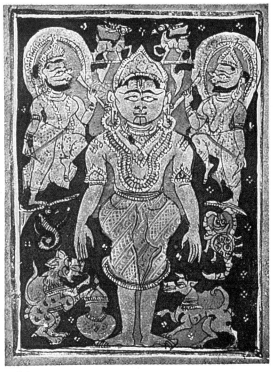

25

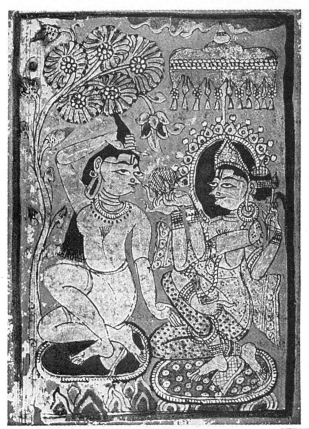

26

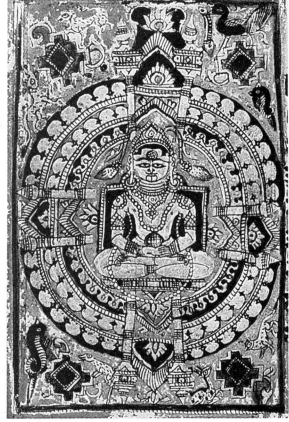

27

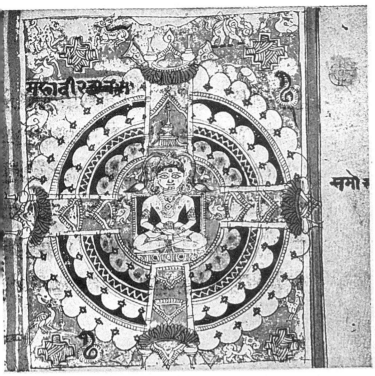

28

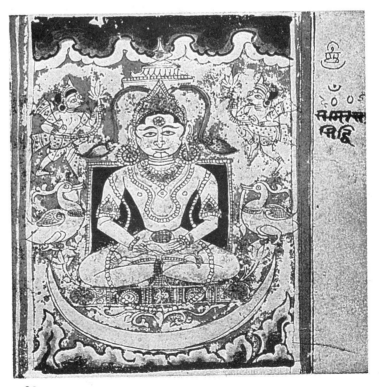

29

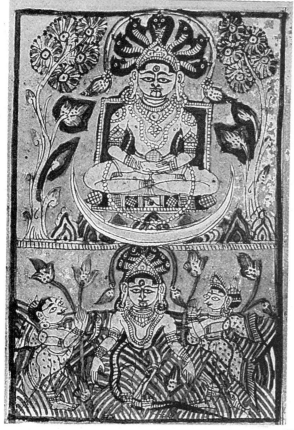

30

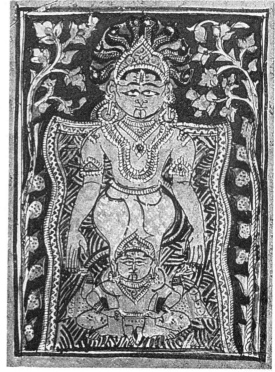

31

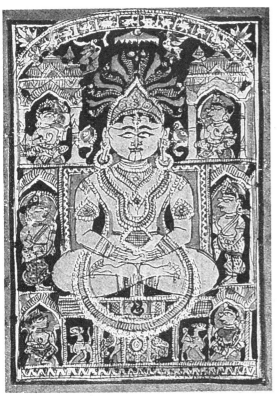

32

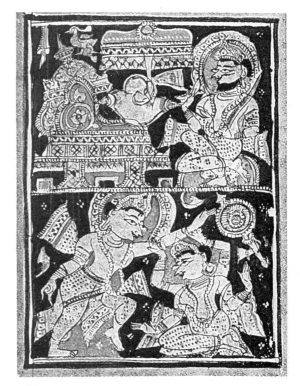

33

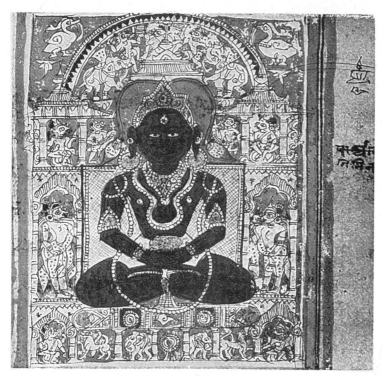

34

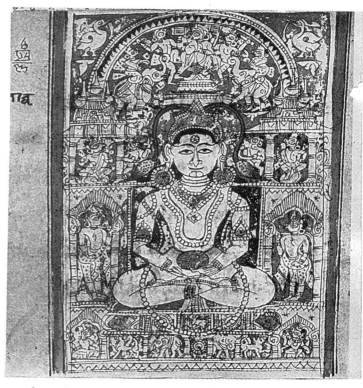

35

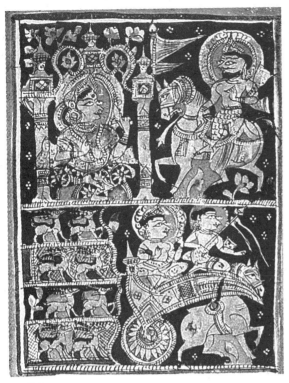

36

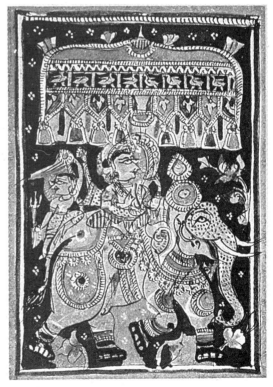

37

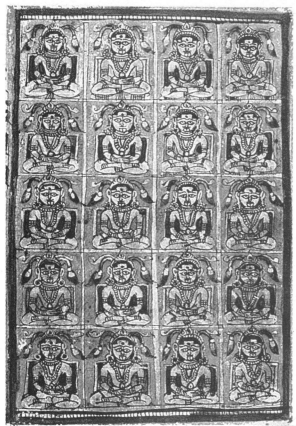

38

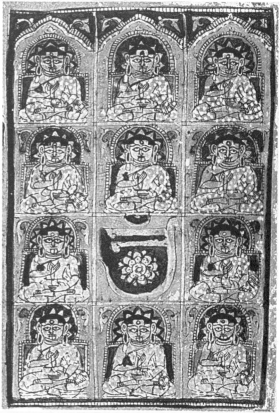

39

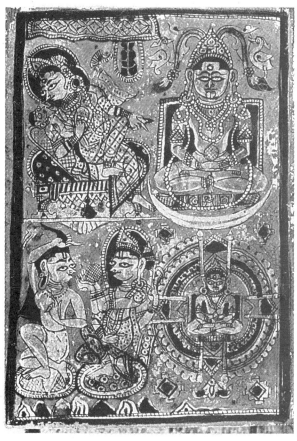

40

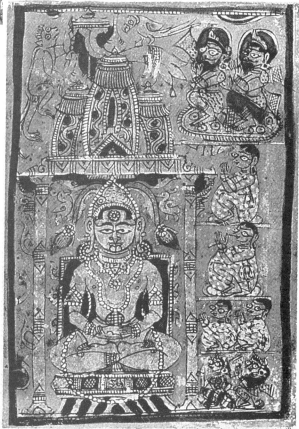

41

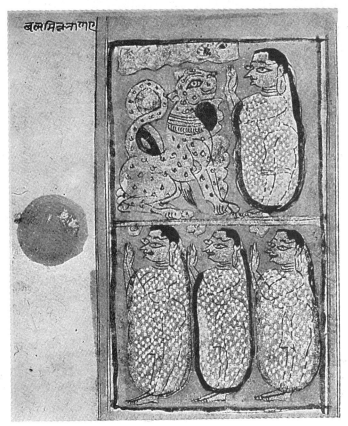

42

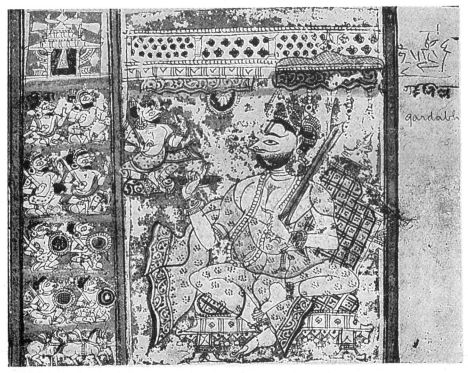

43

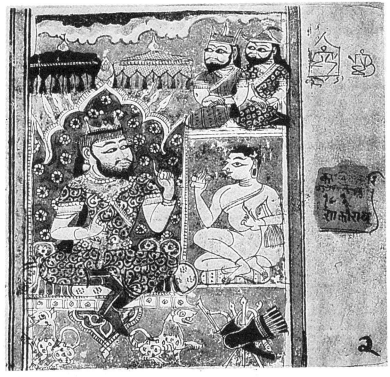

44

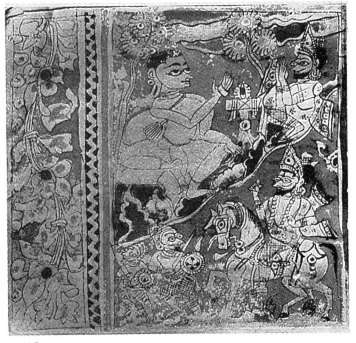

45

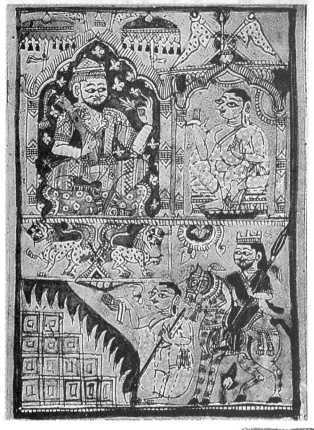

46

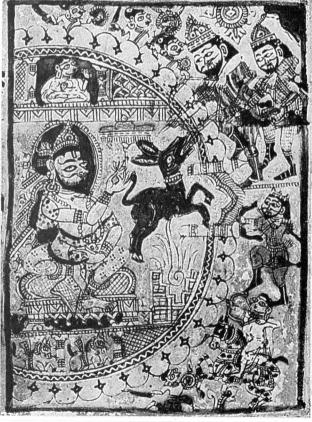

47

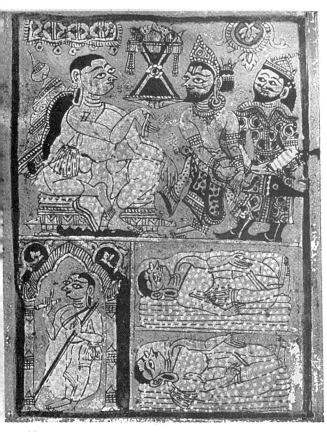

48

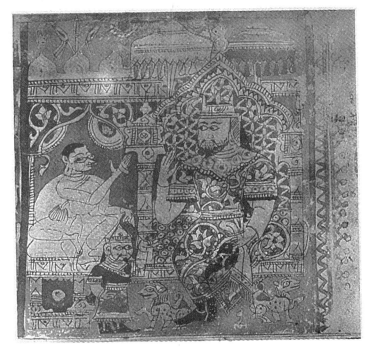

49

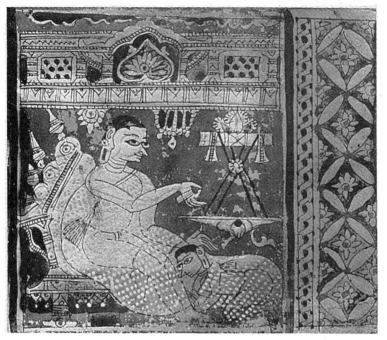

50

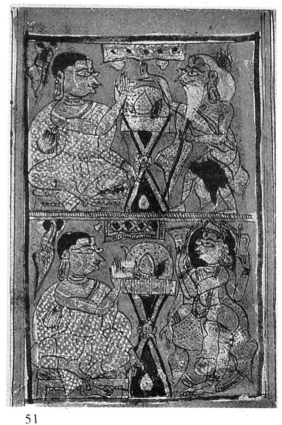

51

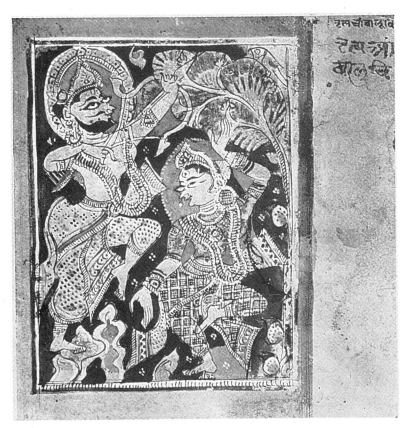

रलचीबाद्वा

रहश्रीं
बालसिंह

52

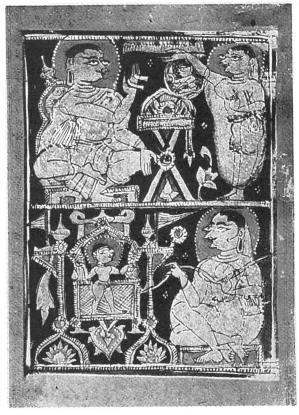

53

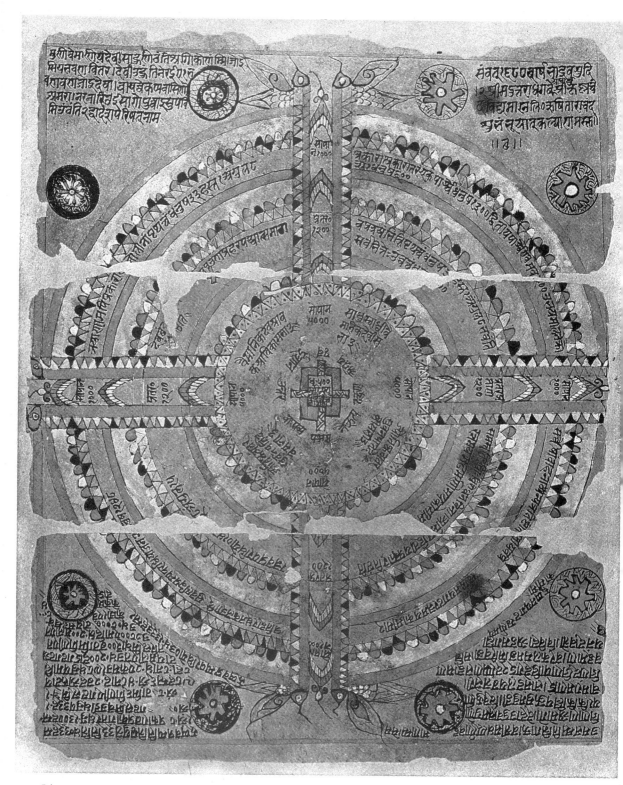

54

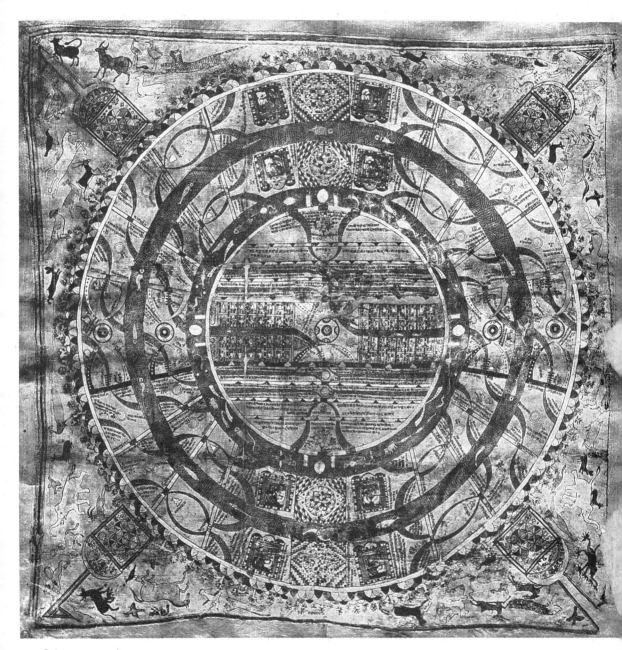

56

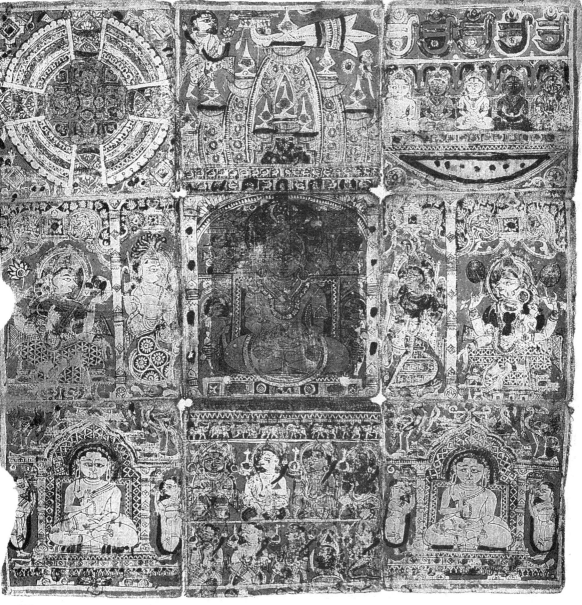

57

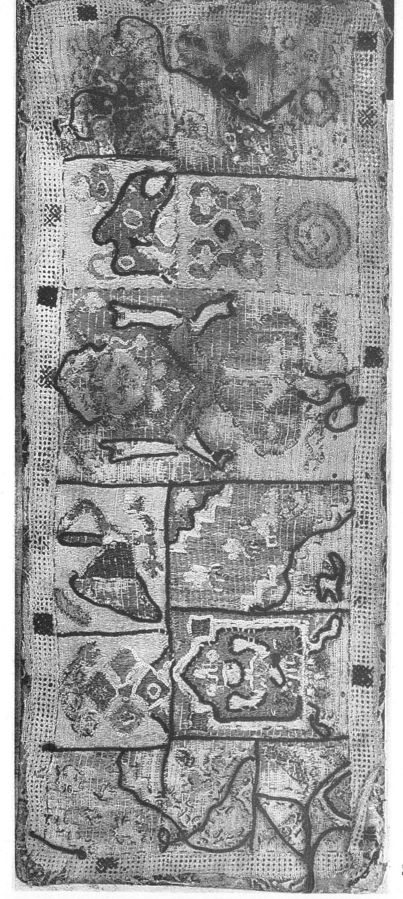

58

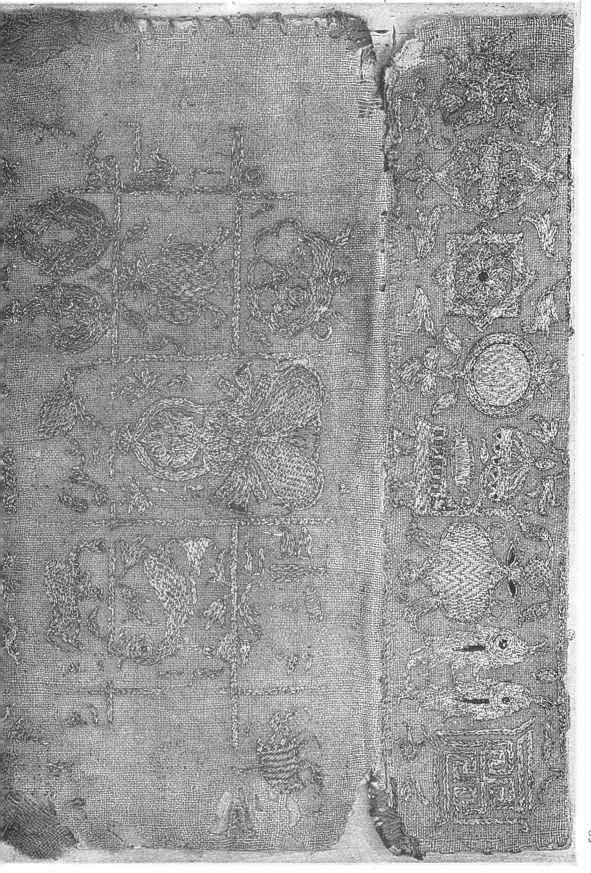

59

60

61

62

63

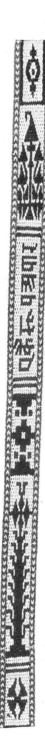
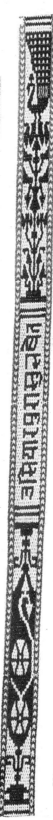

64

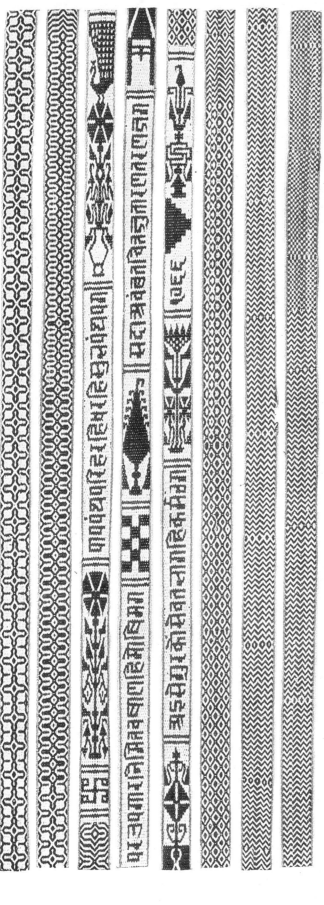